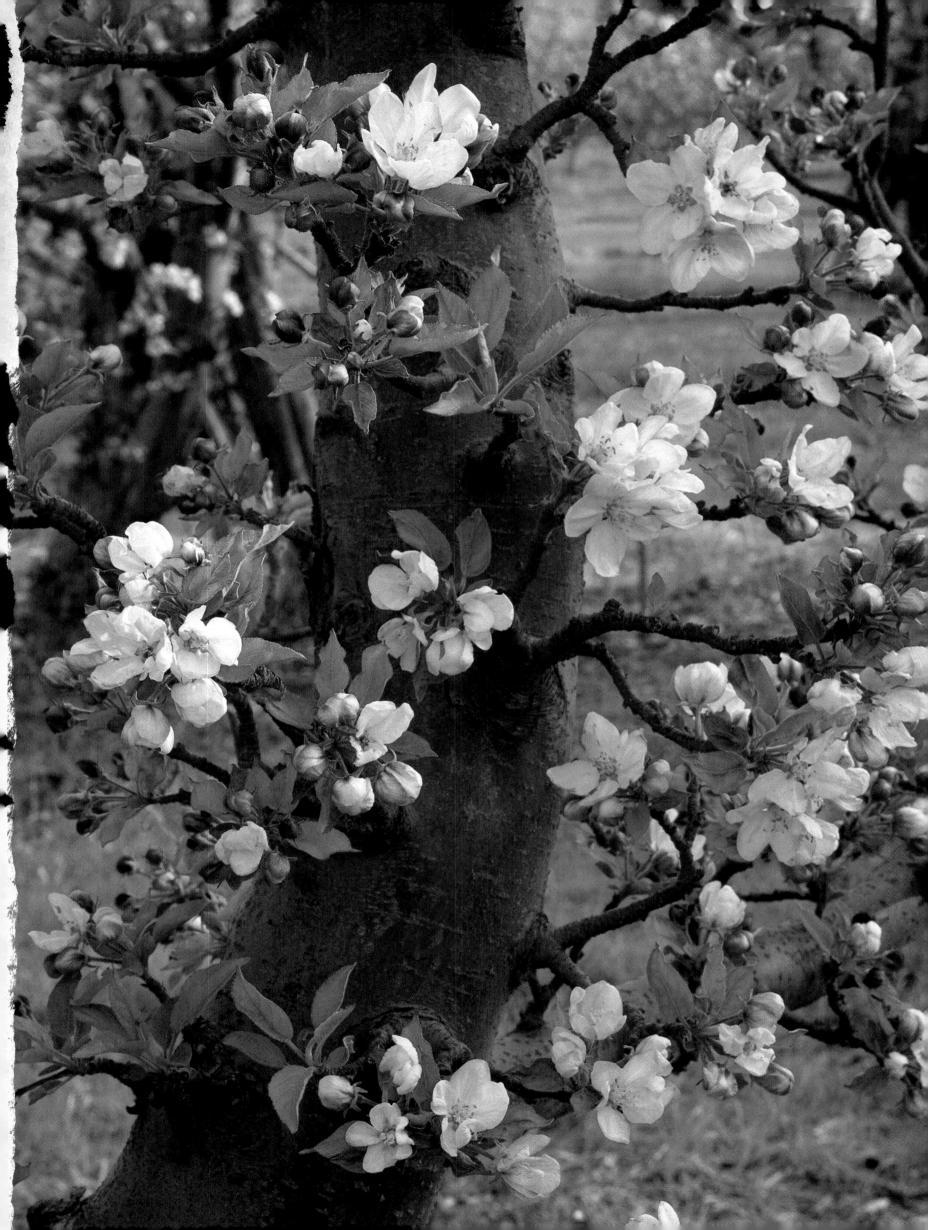

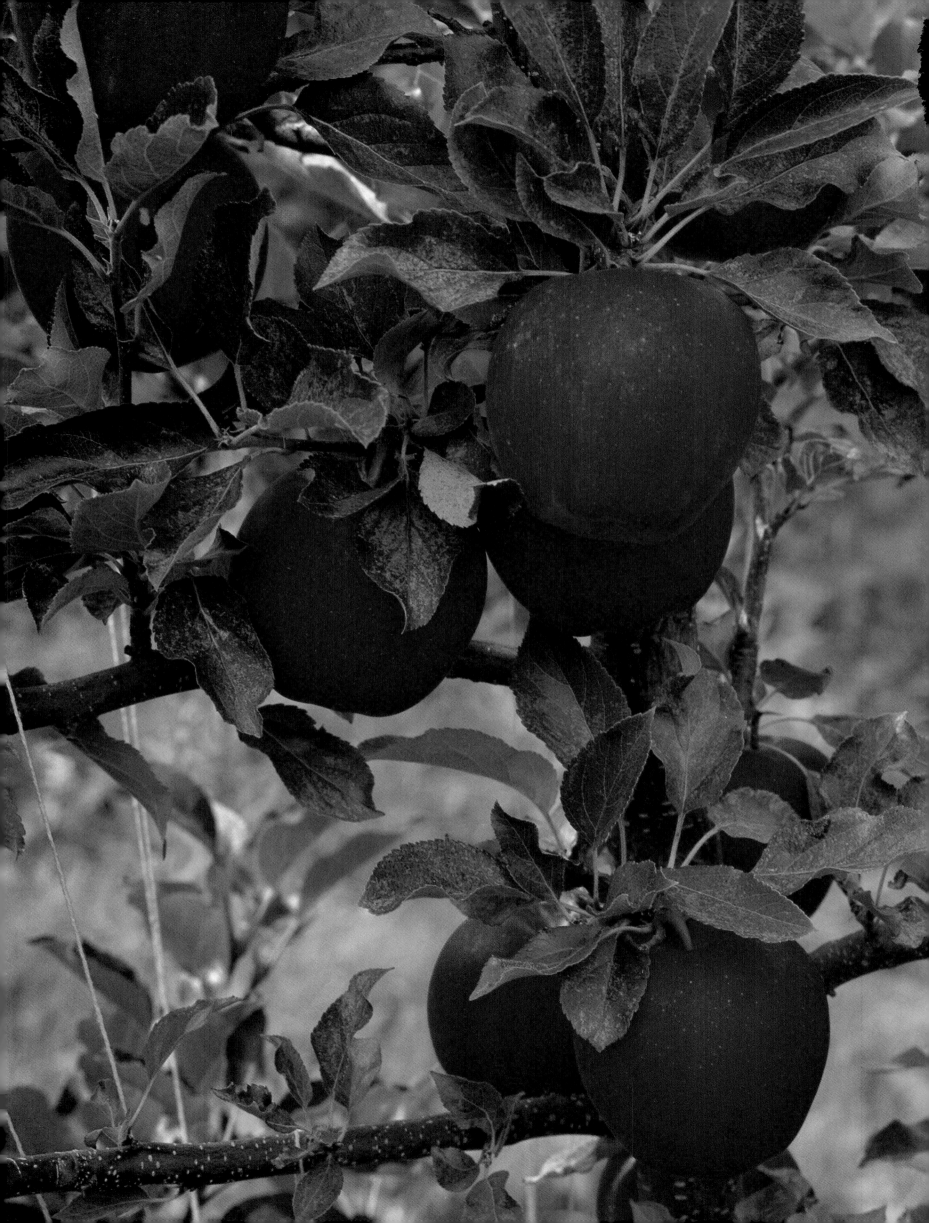

WASHINGTON APPLE COUNTRY

Photography by John Marshall ◆ *Essay by Rick Steigmeyer*

GRAPHIC ARTS CENTER PUBLISHING®

International Standard Book Number 1-55868-240-6
Library of Congress Cataloging Number 95-75450
Photographs © MCMXCV by John Marshall
Essays and captions © MCMXCV by Graphic Arts Center Publishing®
P.O. Box 10306 • Portland, Oregon • 503/226-2402

President • Charles M. Hopkins
Editor-in-Chief • Douglas A. Pfeiffer
Managing Editor • Jean Andrews
Photo Editor • Diana S. Eilers
Production Manager • Richard L. Owsiany
Designer • Robert Reynolds
Illustrated Map • Rolf Goetzinger
Book Manufacturing • Lincoln & Allen Company
Printed in the United States of America

Acknowledgments

The photographer would like to thank all of the growers, field men,
orchard managers, and workers who were always generous in
providing access and photo opportunities. Special thanks to Grady
and Lillie Auvil, Vicki Scharlau, Jim Balck, Ted Alway, and the
Washington Apple Commission for their support and advice.

Page 1: Fragrant blossoms signal the start of each new apple crop.
Frontispiece: Sweet and sensuous, the Royal Gala is one of several new
apple varieties used by Washington growers to revitalize their orchards.
Below: Apple box labels of decades past are now valued by collectors.

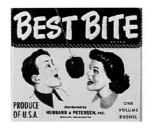
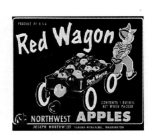
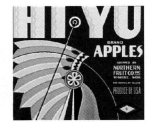

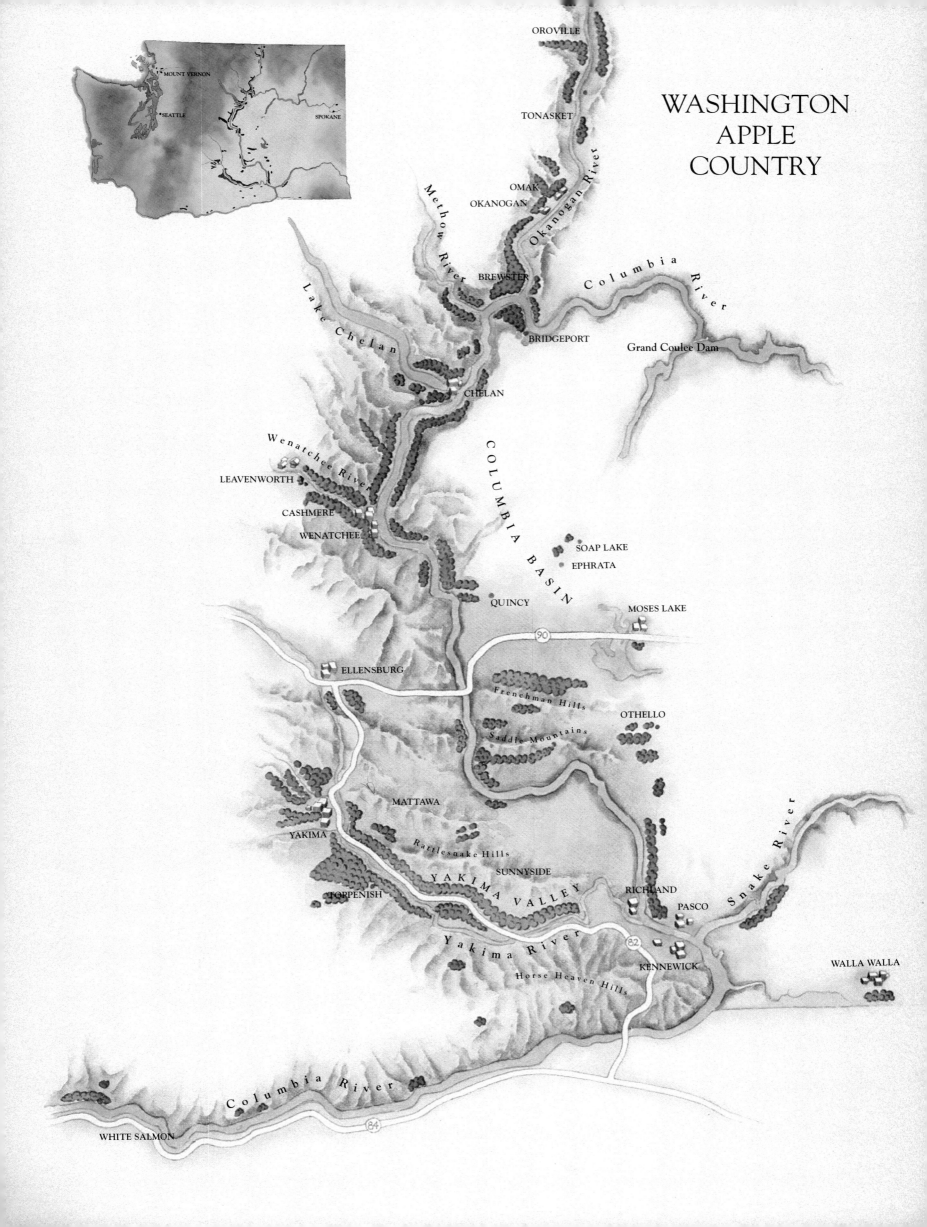

WASHINGTON
APPLE
COUNTRY

MOUNT VERNON

SEATTLE

SPOKANE

OROVILLE

TONASKET

OMAK
OKANOGAN

Methow River

Okanogan River

BREWSTER

Columbia River

Lake Chelan

BRIDGEPORT

Grand Coulee Dam

CHELAN

Wenatchee River

LEAVENWORTH

CASHMERE

WENATCHEE

COLUMBIA BASIN

SOAP LAKE

EPHRATA

QUINCY

MOSES LAKE

90

ELLENSBURG

Frenchman Hills

OTHELLO

Saddle Mountains

MATTAWA

Snake River

YAKIMA

Rattlesnake Hills

SUNNYSIDE

RICHLAND

YAKIMA VALLEY

PASCO

TOPPENISH

82

WALLA WALLA

Yakima River

KENNEWICK

Horse Heaven Hills

Columbia River

84

WHITE SALMON

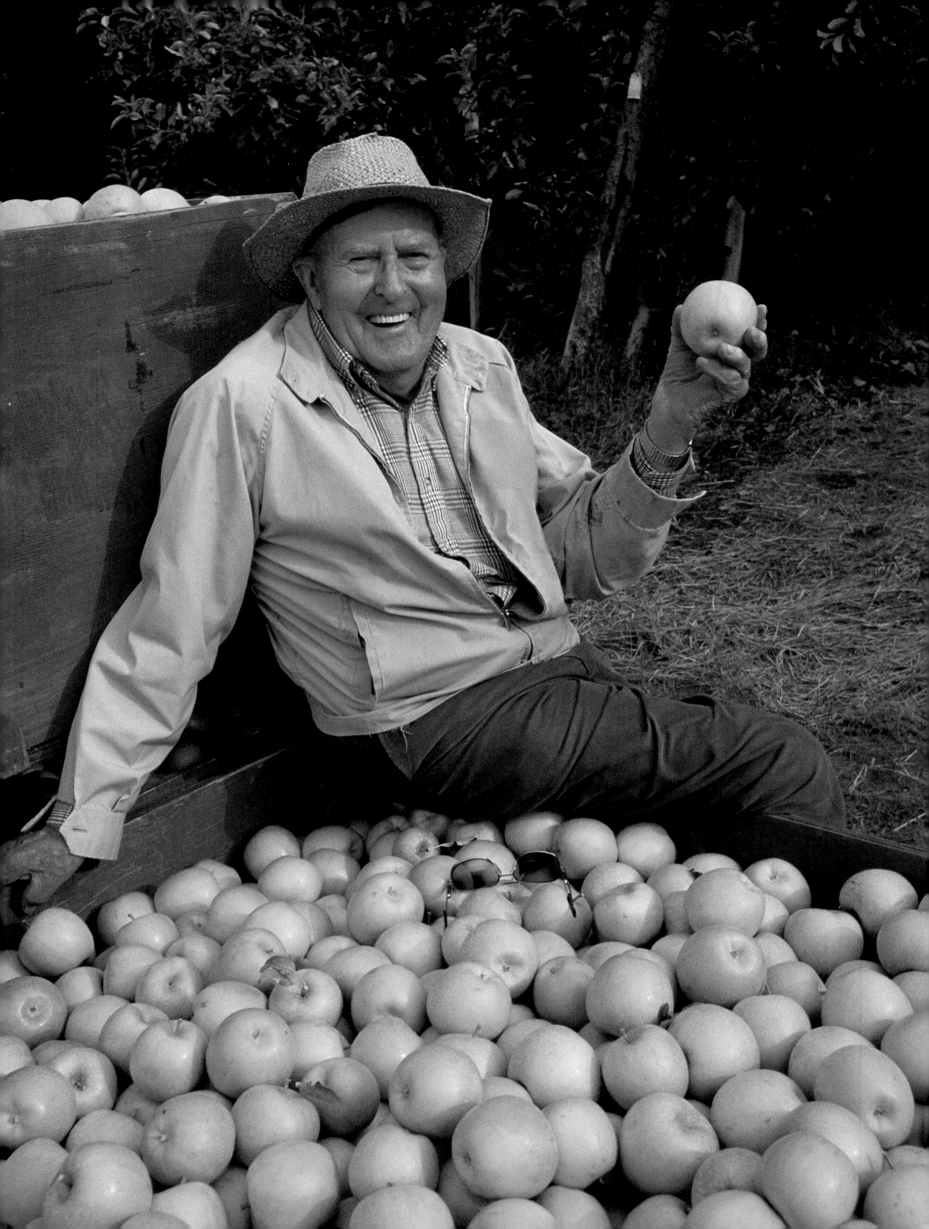

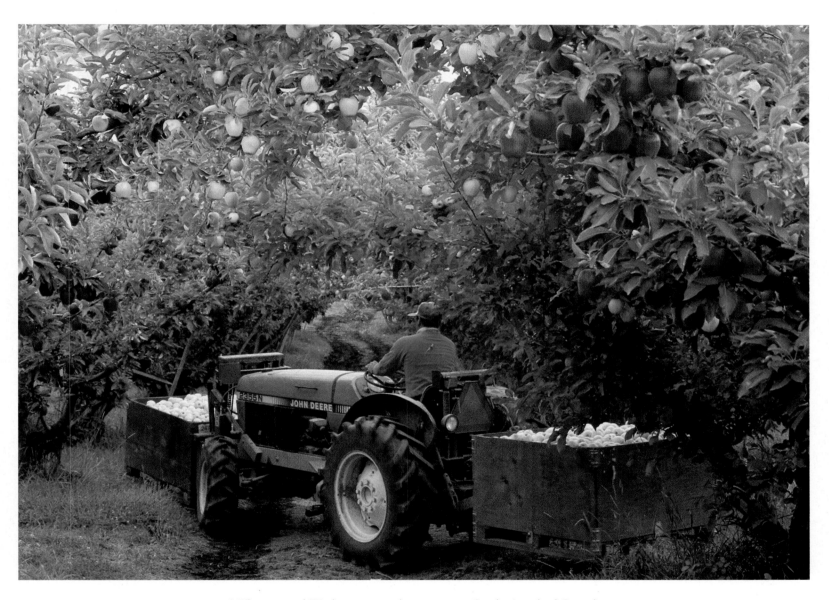

◁ The guru of Washington apple growers is Grady Auvil of Orondo. Auvil pioneered the state's Granny Smith and Fuji apple industries as well as its first commercial crops of Rainier cherries and RedGold nectarines. △ Bins of Golden Delicious apples are tractored out of an organic orchard above Lake Chelan. ▷ ▷ Years ago, branches of Golden Delicious were often grafted into huge Red Delicious apple trees after growers learned it took pollen from both varieties to get a crop of reds. During pollination, bees don't have to travel far in these trees.

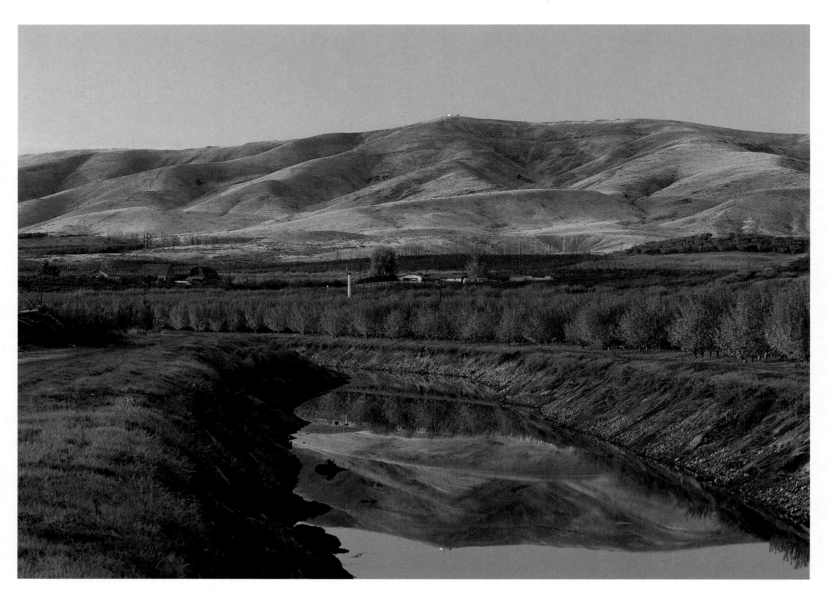

△ The still surface of Yakima Valley's Sunnyside Canal reflects the Rattlesnake Hills and the fall colors of orchards—apple, pear, plum, cherry, apricot, peach, and nectarine. ▷ Golden Delicious is the state's number two apple variety and a favorite with both growers and consumers. Its sweet, delicate flavor is perfect for eating fresh or cooking.

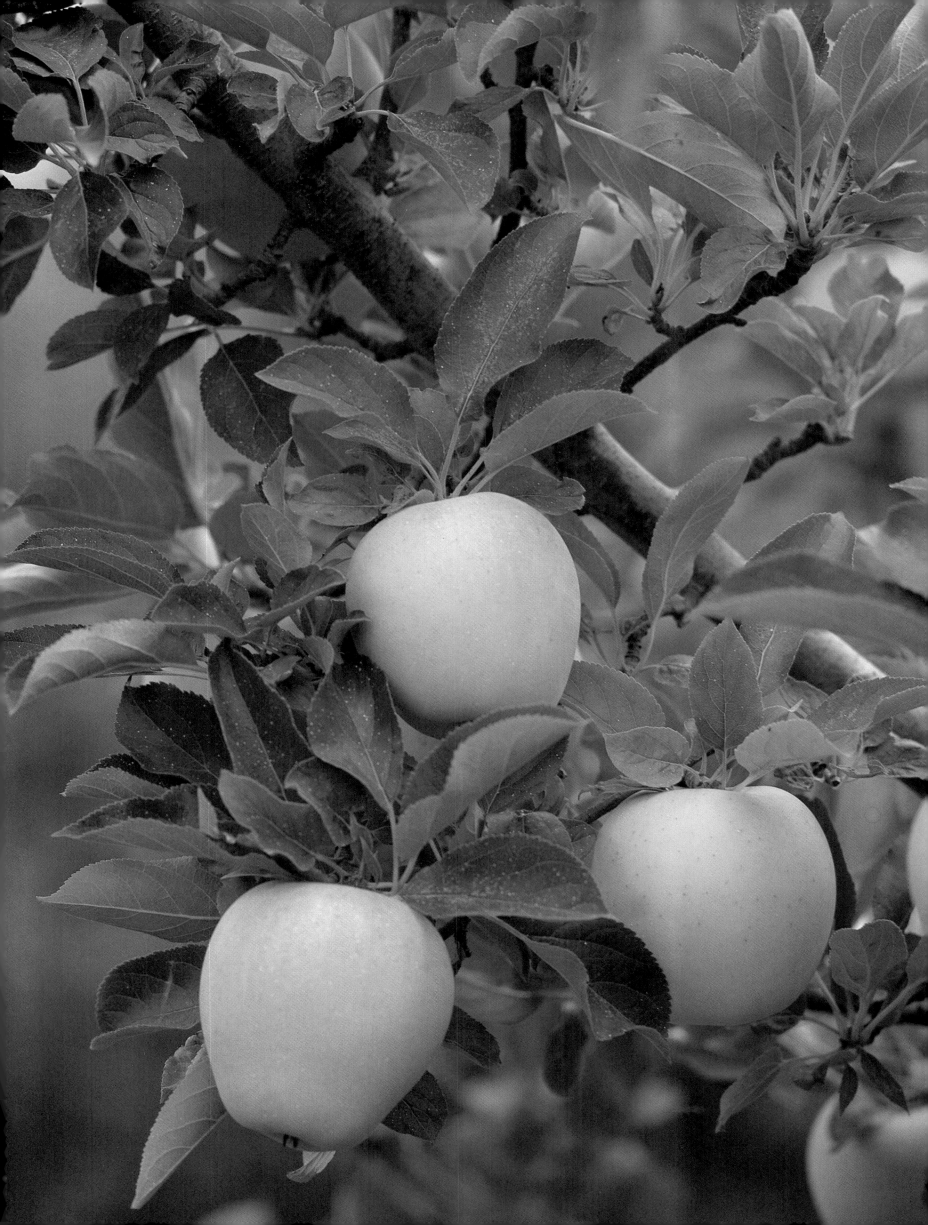

◁ A d'Anjou pear orchard in full bloom is contrasted by the yellow flowers of native arrow-leafed balsamroot in an orchard north of Blewett Pass on Highway 97. △ A Sunnyside apricot orchard shows fall color. Washington is second only to California as a producer of apricots.

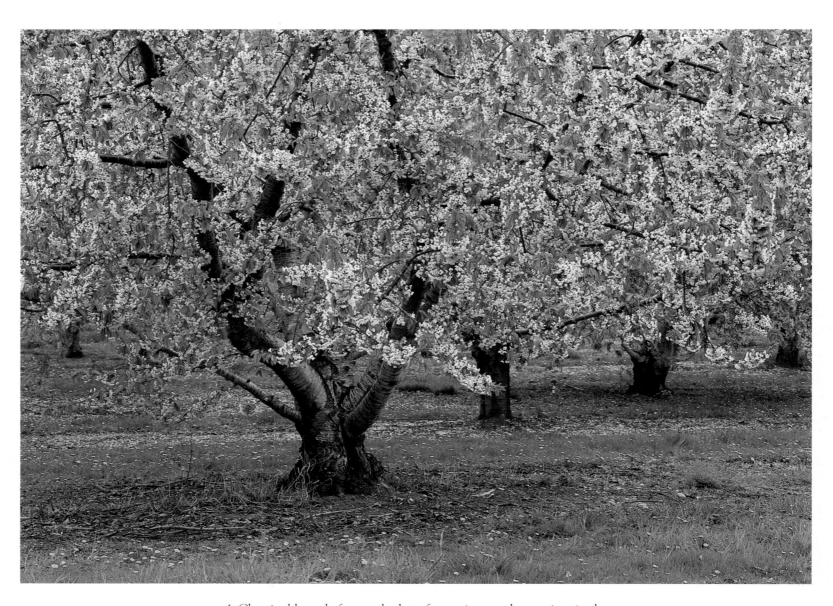

△ Cherries bloom before apples but after apricots and nectarines in the spring. Washington is the nation's leading producer of sweet cherries. Much of the summer cherry crop is exported to Japan and other foreign countries. ▷ Granny Smith, Golden Delicious, and Jonathan are old favorites to pie makers. These apples all have a sweet yet tart taste that makes them excellent for cooking as well as for eating fresh out of hand.

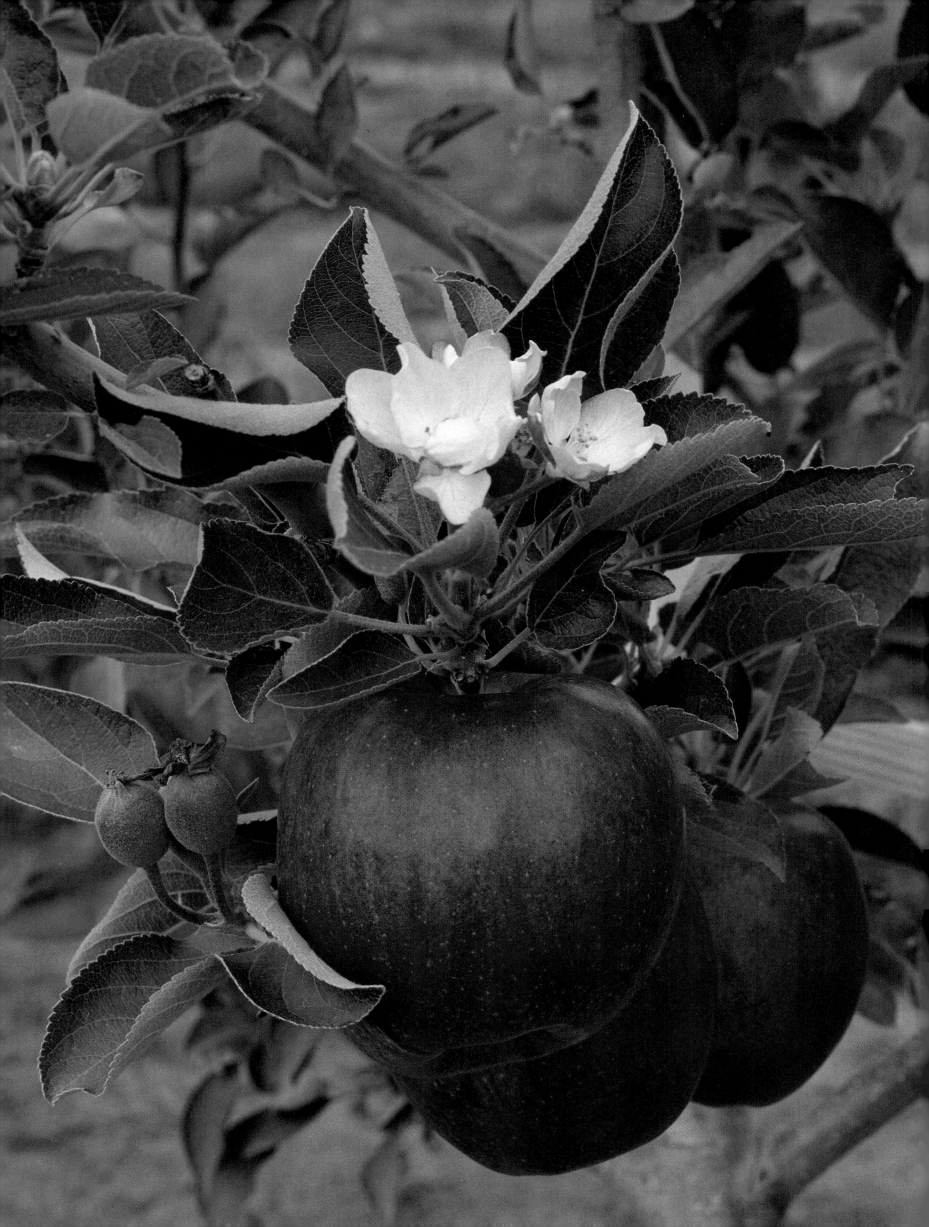

Apple Country

A net of agriculture lies over Central Washington's rugged, arid hills and valleys, like a fisherman's net cast atop ocean waves. That net is a gridwork of orchards, canals, and roads that lead to towns where packing sheds, warehouses, and processing plants clatter and hum and steam. A closer look reveals trees—apple, pear, cherry, apricot, peach, plum, and nectarine. A few sprawl, knotty with years of manicure, their thick, dark bark telling of a hundred or more harvests. Most, however, are armies of young trees that stretch east from the mountains into open land— millions of them in straight, uniform rows. Look away from the deep, narrow river valleys where orchards first took root toward the wide, open basins east, and see an industry that stretches seemingly forever into a land as vast as its future.

To most, it is an unknown land. Washington Apple Country is a place of mythological proportions. Few know much about the state's sparsely populated central region. Although many associate Washington with evergreen trees and rain, the area east of the Cascade Mountains, in both climate and culture, is as different from Seattle and Western Washington as California's coast is to rural Arizona. To some who have never been there, and to many who have, its agricultural products conjure up visions of paradise—a lush land where fruit grows like nowhere else. To others, it may be just a place in the back of the grocery store or a mysterious name on an apple box.

The fame of Washington's apples, like that of Idaho potatoes, Kansas wheat, or sparkling wine from Champagne has gone far beyond a knowledge of the region itself. Product and place, of course, are related. Washington apples are famous because of where they grow, the place being a composite of the land, its unique ecology and weather, and its people with their history and sense of future. To appreciate Washington apples, in a sense, one needs to know about the country. Conversely, apples were the vision that, within a century, inspired pioneers to turn a desolate land of volcanic ash, gravel, silt, and sagebrush into one of the world's great fruit-growing industries.

"We stand on the shoulders of our forefathers," said Tom Mathison, a cheery man in a business suit who talks with a folksy style that belies his native roots. From high above Wenatchee on a parcel of rugged land homesteaded by his grandfather in the 1890s, Mathison and his family have carved an orcharding enterprise that has pockets in every growing region in the state, and markets in foreign countries around the world.

"The fact of the matter is that without them, we wouldn't be where we are today," he said at an informal gathering over beer. Oddly enough, we were not in apple country at all, but in a hotel bar in Tokyo, celebrating the arrival of the first Washington apples imported by Japan. Some had been packed by his own

◁ *Simultaneous blossoms, fruitlets, and ripe Braeburn apples are an unusual sight in Washington orchards. A short growing season normally allows only one bloom. This abnormal configuration, found in an East Wenatchee orchard, was caused by an extreme fluctuation in weather patterns. The Braeburn apple itself is a new sight to Washington orchards; originating in New Zealand, the variety is now planted heavily in the state.*

Stemilt Growers; others came from other growers and packers like him with the persistence and drive to bring Washington apples into yet another major market. Although Mathison's comment paid tribute to pioneers who dug the first canals and planted the first seeds of Washington's infant apple industry a hundred years before, the setting symbolized just how far the industry had come.

Today, the region produces close to one hundred million boxes of fresh, packed apples each year, more than half the nation's total apple supply. Stacked side by side, that is enough apples to reach to the moon and halfway back, or to build a road from Seattle to New York sixty-five apples wide. During a normal harvest season, fifty thousand workers pick some fifteen billion apples off more than thirty-five million trees. F.O.B. returns total more than one billion dollars annually.

Follow the Okanogan River down from its source in Canada and across the border, and you find Washington Apple Country, approximately 225 thousand acres of the world's best orchards. Drive U.S. 97 through towns with Indian names like Tonasket and Okanogan until you reach the confluence of the mighty Columbia River. Farther south, the Methow River flows in at Pateros, followed by the overflow from fifty-five-mile-long Lake Chelan. At Entiat and Wenatchee, other river valleys stretch out west to Ardenvoir and farther south, to Cashmere, Dryden, and Peshastin—tiny towns famed for orchards that produce the world's finest pears. The wider Wenatchee confluence is famous not only for its apples, but also for its sweet cherries. Follow the Columbia east toward Quincy, then south to Vantage, and you will find more orchards—apples, pears, cherries, peaches, plums, and apricots, as well as a myriad of vegetable and grain crops. Wind through the Columbia Basin on back roads to Yakima and you will find grapes and hops. Drive through Moxee, Selah, and south to Naches, then circle east past Yakima to Wapato, Toppenish, Zillah, Sunnyside, and Prosser. This is America's fruit bowl, a cornucopia of agricultural wealth. At Pasco, the Snake River joins up to give the Columbia power to flood through the spectacular gorge along Oregon's northern border to the river's mouth at Astoria, west of Portland.

All of these towns and many more are in Washington Apple Country. So are the people who live here. They are the people who came to grow orchards generations ago, and they are those who came yesterday to harvest the fruit and work in the packing sheds. Washington Apple Country is picturesque clapboard farmhouses and modern fruit storage plants. It is churches, schools, and city halls. Stop along a desolate road in the basin and pick up a handful of dry, sandy soil that wants to blow with the tumbleweeds. That is Washington Apple Country, too.

Eons ago, Central Washington's landscape was created by lava flows from a line of volcanoes to the east that now make up the Blue Mountains. On top of the glassy basalt and granite, volcanic ash settled, in some areas hundreds of feet deep, from volcanoes in the Cascade Mountain Range to the west.

Much later came the floods. Swollen by melting glaciers, the Columbia grew huge—to ten times the flow of all the rivers in the world today, according to John Eliot Allen in his book, *Cataclysms on the Columbia.* The book is based on the studies of geologist Harlen Bretz, who first documented the theory of a huge lake covering much of Western Montana more than fifteen thousand

years ago. Formed by a melting ice cap, Lake Missoula covered at least three thousand square miles and was up to two thousand feet deep. Ice dams lifted periodically, causing floods to inundate sixteen thousand square miles to the south and west to depths of hundreds of feet. The flood left some areas as scablands with bottomless gravel pits. Others became the silt-filled banks and deltas that gave birth to the state's agricultural wealth and fame.

Settlers began planting apples in Washington's central basins east of the Cascade Mountains early in the 1800s, with commercial orchards becoming popular near Yakima by the 1890s. By 1905, a planting craze gripped the area, largely the result of land agents who had lured pioneers to the area with promises of the stress-free life of the apple grower. One 1910 promotional flier depicted Wenatchee as "the gateway to the land of perfect apples." The work of growing apples was hardly the life of leisure advertised, but those with horticultural talent and persistence found success, and by 1920, Washington's apple industry had become the nation's largest, according to information compiled by the Washington Historical Society.

Most orchards were planted along the banks of large rivers for irrigation and transportation purposes. The Columbia River and its major tributaries—the Okanogan, Wenatchee, Yakima, and Snake Rivers—remain the state's principal growing regions. Steamboats on the Columbia provided an important source of freight transport around the turn of the century.

Before 1900, John A. McArthur loaded his apples on a horse-drawn wagon and drove them from his Entiat River Valley orchard three miles east to the Columbia. There, they were loaded on a sternwheeler and shipped fifteen miles to Wenatchee or points farther south. Rail service became available at Wenatchee by 1893, with car-lot shipping starting in 1901. A rail spur to Entiat was completed by 1913. J. K. McArthur Jr., McArthur's grand-son, turned forty acres of orchard into five hundred acres of apples, pears, and cherries. In 1980, he sold the Entiat orchard to Naumes, Inc., a Northwest family-owned fruit company that today owns thousands of acres of orchard land.

Although trends favor larger corporate farms, families still own and operate the majority of Washington's apple acreage—more than 170 thousand acres, with the average orchard being about forty acres. About four thousand apple growers are registered with the Washington Apple Commission. But progressive apple growers have moved away from the tall, sprawling trees planted by their forefathers. Nearly gone from commercial production are the Winesaps, Jonathans, and Common Delicious that brought the state apple industry into prominence. An evolution of different strains of the state's predominant varieties, Red and Golden Delicious, has replaced most of the older varieties.

In the last decade, movement has been rampant to plant smaller trees closer together to try to get the newest strains and entirely new apple varieties into production quickly. Instead of replanting old orchard land in the scenic river valleys where they live, many growers and larger corporations have moved east into the central Columbia River Basin where irrigated virgin land can still be found at a reasonable price. The region's deep, volcanic ash soil and desert climate perfectly suits modern high production growing methods—methods designed through science and experience to match the needs of a growing world economy.

Mythology & Early History of the Apple

The apple may be a symbol of health, nutrition, and good fortune today, but the history of its importance to mankind goes far beyond its association with Washington's fruit industry. The apple, in fact, existed long before man knew how to document his thoughts and actions. Folkloric references take it back to the beginning of time. The apple is known as the fruit that brought about man's downfall and caused him to be cast from the Garden of Eden. In his book, *Apples: History, Folklore, Horticulture and Gastronomy*, Peter Wynne presents the apple as an ancient symbol of love and of life itself. The forbidden fruit from the Tree of Knowledge of Good and Evil in the Bible was widely thought to be an apple. In pagan lore, the apple was the fruit of knowledge of life and death.

Throughout history, from the earliest written accounts, the apple has been held in high esteem for its food and symbolic value, showing up time and time again both in legend and in art as an irresistible object of desire. The Bible, however, makes no reference to the apple as the forbidden fruit. No one really knows how the "tree which is in the midst of the garden" became an apple tree. According to Elizabeth Helfman, in her book, *Apples, Apples, Apples*, the fruit did not even grow at that time in the part of Asia Minor where the Garden of Eden was supposed to have been.

Regardless, in the biblical account recorded in Genesis 3:1-6, God told Eve that eating—or even touching—the fruit of the tree would bring death. The serpent that confronted Eve, however, convinced her that eating the fruit would not make her die, but instead would open her eyes and make her a god, knowing good and evil. She took the fruit, seeing it as pleasant to the eyes, good to eat, and—believing it would make her wise—gave it to Adam.

Wynne believes biblical accounts refer to pagan belief in an Apple Goddess who was mother of all men. Her sacred emblem, an apple, signified love, knowledge, and immortality. He substantiates his theory with thorough research of the myths of Rome and Greece and the folklore of Christian Europe, where countless references are found to the apple as a symbol of life and love, unobtainable desire, and also as a cure for many illnesses.

Whether or not Wynne's speculation about the roots of the apple's symbolic importance has merit, the apple's longevity as a symbol of love and health is obvious. References exist from before the birth of Christ to the use of apple seeds as a method of determining one's fate in the arena of love. In a way, The practice continues to this day, in the form of the apple bobbing contest. Traditionally, the games are played on Halloween. In some versions of the game, apples are labeled with names of a young woman's possible suitors before being placed in the barrel

▷ *Near Monitor, snow cloaks a young, high-density apple orchard like a cotton blanket. During the cold winter months, apple trees go dormant, which enables them to sustain temperatures that may range to well below zero. A thick covering of snow protects the trees from frigid winds and provides them with a natural reservoir of water as the snow melts in the spring, thus making them less dependent on spring rains.*

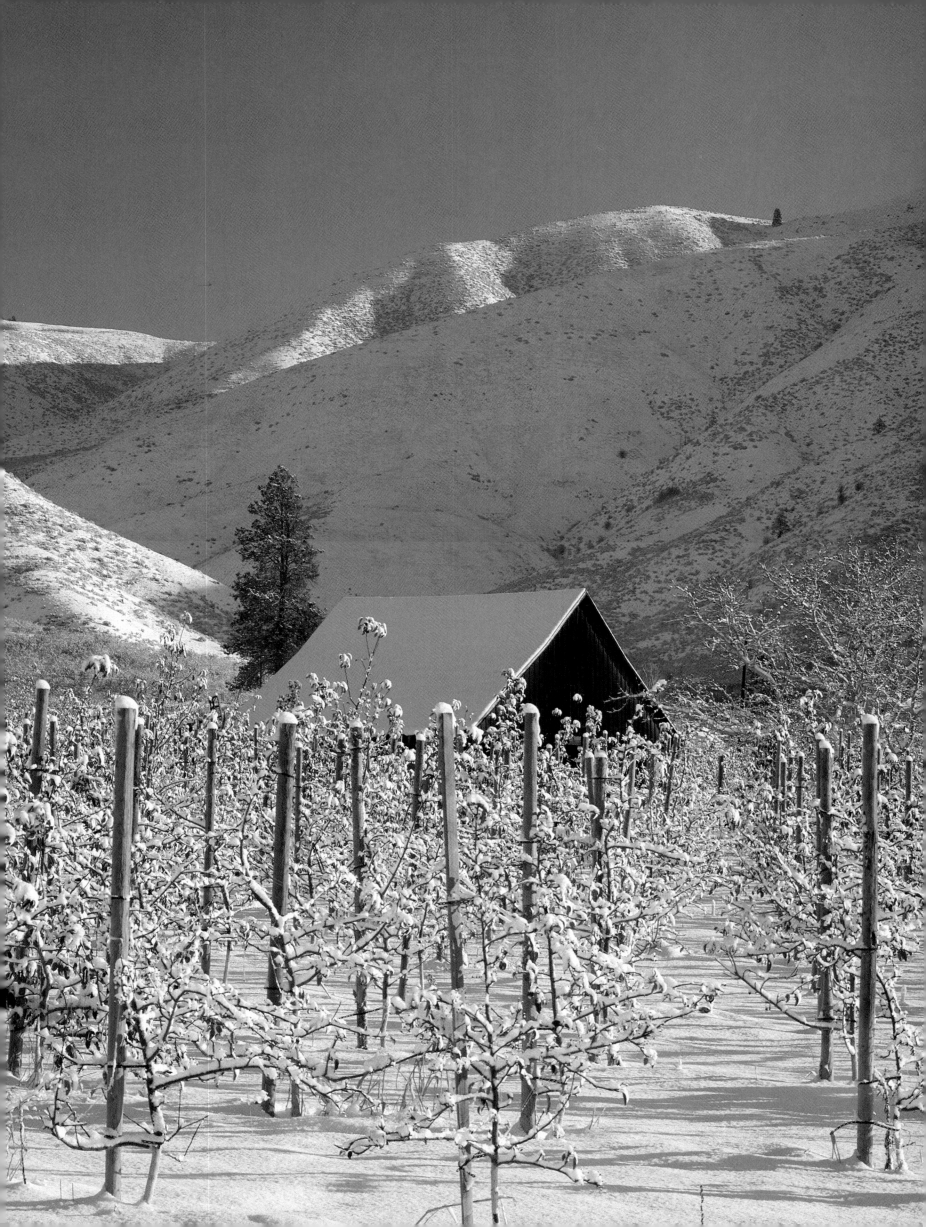

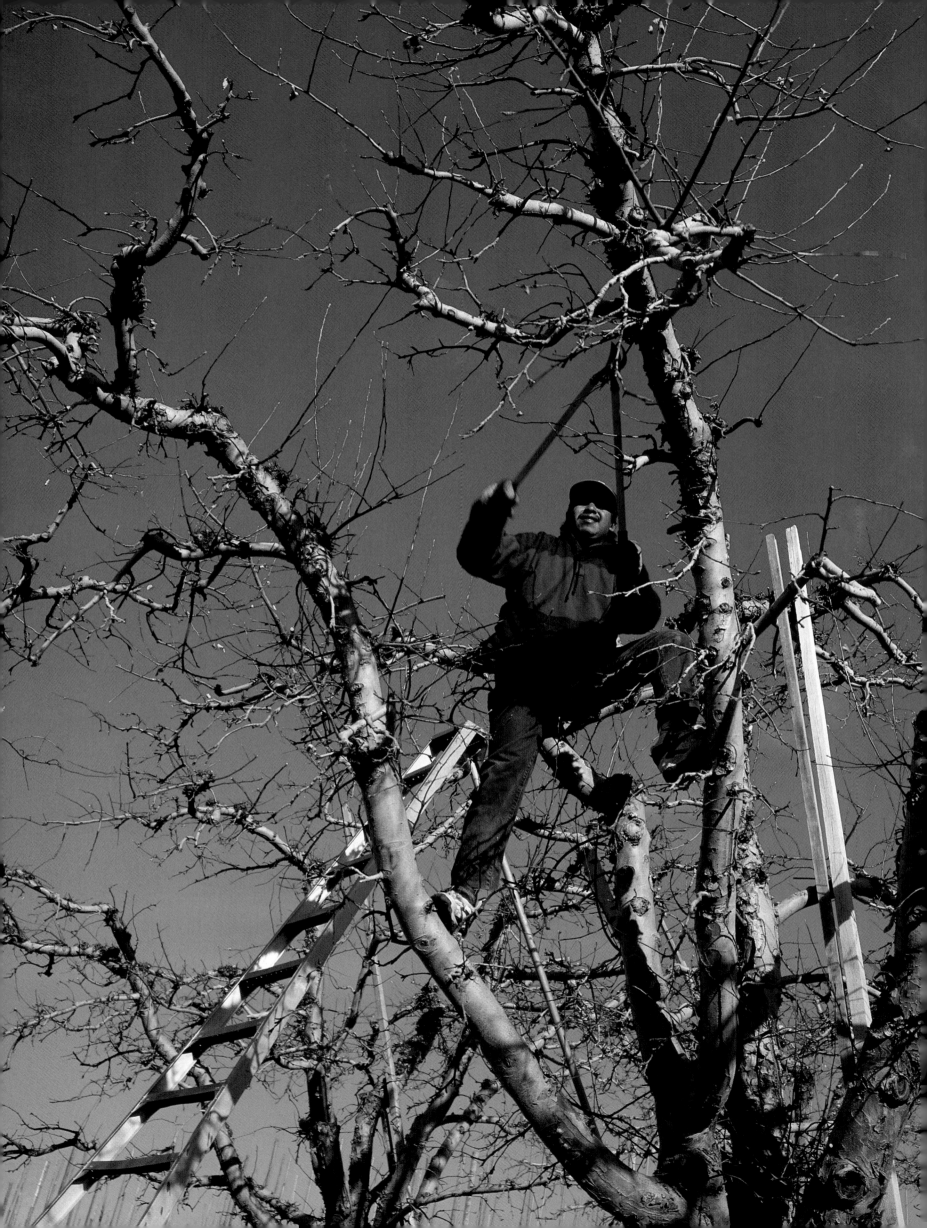

for bobbing. The apple she catches with her teeth has the name of the man who will become her husband. Another tradition involved peeling an apple with a knife and throwing the peel over your shoulder. The peel lying on the ground was supposed to form the initial of your lover's name. James George Framer's *The Golden Bough* refers to a Halloween tradition that instructs a woman to slice an apple, holding each slice on the point of the knife over her left shoulder while combing her hair before a mirror. The specter of the woman's future husband was supposed to appear in the mirror behind her and take the slices of apple from the knife.

The ancient apple is believed to come from the Caucasus, a mountain range between the Black and Caspian Seas. Located in the former Soviet Union, the region is thought to be the origin of tribal ancestors of modern Europeans. The first true apples are believed to be a cross between European and Asiatic crab apples, both of which are still found in the Caucasus. Going back further, around 2,500,000 B.C., are the bitter, wild crab apples probably eaten like berries by ancient man. Fossils of European crab apples have been found among prehistoric remains in Switzerland.

The Greek poet Homer makes the first historical mention of apples in *The Odyssey*, written sometime between the twelfth and seventh centuries B.C.. It is believed that the Greeks cultivated seven apple varieties. History makes little mention of apples before the second century B.C., when the Roman, Marcus Portius Cato, wrote a book simply called *De Agricultura*, which offers a still-valuable lesson on grafting, as well as on sacrifices

◁ *Near Monitor, a pruner climbs off his ladder and into an older, open-centered apple tree to lop off suckers and unproductive branches. Orchards are pruned each winter to revitalize the trees for the coming crop.* ▽ *Near Mattawa, a mature block of apple trees planted in a Tatura trellis strikes a geometric pose. The V formation maximizes light penetration resulting in a profusion of blossoms in spring, a high percentage of which set fruit. Fruit that receives adequate light grows to good size and takes on attractive color. Wires are necessary, particularly when the trees are young, to support the heavy loads of fruit that would otherwise break branches and trunks.*

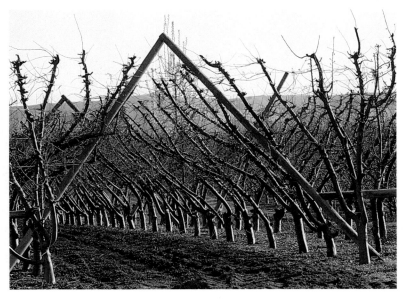

to tree spirits and the treatment of slaves. Another Roman, Pliny, in A.D. 77, completed a thirty-seven-volume work on natural history, which included a good description of ancient apples. Pliny mentions a Syrian red apple called *orthomastion*, meaning "upturned breast," because it resembled a woman's bosom. One variety, cultivated by the Romans and described as a golden yellow that developed a red cheek when ripe, may be an ancestor to today's apples.

Europeans ignored the Romans' knowledge and took their own slow route to developing agriculture, learning something of the art of growing fruit from the followers of Islam, who had conquered parts of Spain and France by the eighth century. The English grew trees from seed and used the apples to make cider. No two trees were alike, but the result was a good blend for juice and alcoholic beverages.

The French were more interested in apples as a dessert fruit and became more involved in breeding. They perfected trellising techniques and used severe pruning to produce large fruit. The trees were also pruned ornamentally like the rose bushes to which apples are related. The French also developed the dwarf apple tree by grafting it to a native wild apple known as a thorn tree. This knowledge spread to England and other countries in the seventeenth century when French guarantees of religious freedom were revoked by Louis XIV, and thousands of Protestant Huguenots, including many skilled horticulturists and artisans, fled the country.

Apples came to America early in the seventeenth century, with the first documented orchard planted around 1625 near Boston. Native crab apples were bitter, chewy, and largely discounted as a source of breeding material until much later. At first, most American apples were used to make hard cider. Europeans brought with them the belief that drinking water would lead to plague and other illnesses. Because a knowledge of bacteria did not yet exist, they assumed that the pure water in America was just as bad as the fouled water of Europe. Cider was one of the easiest spirits to make, and seedling apples seemed to grow very well when planted in Colonial America. As in England, there was little motivation to improve on the seedling varieties, although starting in the early eighteenth century, there were a few grafted orchards where specific varieties were cultivated. The Newtown Pippin became one of the most popular varieties developed from seedling.

America's century-long dedication to seedlings gave it a good supply of native varieties to choose from when growers began to get serious about raising apples in the early 1800s. Most of the nearly one hundred varieties offered commercially by nurseries at the time were native to America. As populations expanded northward, growers imported new varieties from northern Europe, Scandinavia, and Russia in an attempt to find trees that could withstand cold winters. By the middle of the nineteenth century, there were more than five hundred apple varieties in cultivation in the United States. By 1872, a copy of Downing's *Fruits and Fruit Trees of America* listed more than one thousand apple varieties. Today, less than one hundred varieties can be found, with far fewer used commercially. However, new varieties are under development at professional breeding stations, and hundreds of new strains are tested each year.

The Life of an Apple

Apples get their start from a tiny seed, no more than a quarter of an inch in length. The process of cross-fertilization is a risky one at best for an orchardist who wants to reproduce a particular type of fruit. Because genetic characteristics are handed down from two parent apple trees, there is no telling what kind of new offspring apple will result. As a result, most growers rely on grafting scion wood of a known variety to a rootstock that has desirable characteristics. Growers can purchase budded trees from nurseries that offer a wide range of varieties and growing characteristics suited to different soils and climates. Growers can also graft their own trees, using scion wood of a desired variety to renew a wild seedling tree or a variety that has fallen out of favor.

Orchards are normally planted in the spring on virgin ground or on land from which an older orchard has been removed. In the case of renewing trees on old orchard land, growers often fumigate the soil to destroy pathogens that could stunt the growth of new trees. When planting, growers choose from a wide range of different orchard systems that best suit their needs. Years ago, orchards were made up of large trees planted at least twenty feet apart at densities of between one and two hundred trees per acre. Today, trees are more likely to be planted closer together, using dwarf rootstocks and often a trellis system to help the trees maintain position. Advantages include earlier production—often within the second or third year—and the lower labor costs inherent in smaller trees that can be pruned, thinned, and harvested with a short ladder or without a ladder. The disadvantages are the high initial costs of purchasing and planting five hundred to a thousand trees per acre and installing expensive trellis systems.

Once the trees are in the ground, they must be pruned and trained into a good framework to produce fruit. Several arrangements are possible, but the main idea is to develop strong, healthy branches that will produce lots of fruit buds, yet allow plenty of light into all parts of the tree so the apples will grow and develop color to their full potential. Often, the young branches are pulled or pushed down just above the horizontal with string, weights, or sticks. Growers have learned that the process sends a message to the tree to produce fruit earlier. Training generally ends when production begins, but pruning will continue to be a major winter activity and expense throughout the life of the tree. Later in the life of the tree, pruning is particularly essential to renew fruit buds, create ladder bays, and expose the fruit buds to light.

Within a few years, the tree produces apples. Buds grow on the young branches. In spring, the buds swell and sprout leaves. As the weather warms, between April and May, the buds blossom with pink flowers. Bees and other insects help spread the pollen produced in one blossom to the stigmas of another. Growers contract with beekeepers in anticipation of this time to bring in hives to aid in pollination. Honeybees are attracted to the blossoms by their smell and color. They fly from flower to flower in search of nectar and pollen. As they perform this quest for food, they spread a tiny amount of pollen from flower to flower.

Occasionally, growers try to boost the pollination process by adding extra pollen to the trees. A few companies, such as Antles Pollen Supplies Inc. in Wenatchee and Firman Pollen Co. in Yakima, specialize in collecting pollen each spring. Employees pick the blossoms off the trees, often beneficially spacing future pieces of fruit in the process. The blossoms are then run through several screens to extract the pollen, which is frozen to be used the following year. Growers add the pollen to a tray in the beehive where outgoing bees pick up a bonus to carry to the blossoms. Some growers try spraying the pollen on the trees. In the past, growers have tried "painting" the pollen on each blossom with a brush, and "shooting" the pollen on the trees using a shotgun loaded with pollen-filled cartridges.

Cold weather may hamper good pollination and also damage the fruit buds. The buds are particularly sensitive to cold around blossom time. Huge fans on thirty-foot masts stand sentinel over the orchards like the windmills of Don Quixote's Spain. When temperatures dip below freezing, the fans are switched on, mixing cold air that settles near the ground with warmer air above. Overhead and undertree sprinklers are also be used to protect blossoms from frost damage. An eerie sight in Washington Apple Country is a frosty spring morning when entire trees may be found encased in ice, the fragile blooms actually *protected* from the cold by a glasslike, frigid shield. Paradoxically, the process of freezing water releases energy in the form of heat. Often, it is enough to keep the temperatures inside the ice slightly above freezing.

There are other dangers. Orchard pest control programs are normally started well before bloom time while insects are still in their dormant stage or just becoming active. Many insecticides are harmful to bees and cannot be used when they are present in the orchards. Other sprays must be applied in the late spring and summer when new insect cycles begin. Pesticides are normally

▽ *The open king bloom is the most likely to produce a large, high-quality apple later in the fruit growing season. Growers normally thin off the side blooms—seen here in their balloon stage—with chemical thinners, or later on, by hand. This thinning allows the tree nutrients to concentrate on giving special treatment to fewer apples.* ▷ *An icicle-draped apple tree is an eerie sight on cold spring mornings. On frigid spring nights, the growers customarily turn on their sprinklers to protect the fragile blossoms from frost damage. Ironic as it may seem, the process of freezing water gives off heat that actually gives protection from the extreme cold to the sensitive fruit buds.*

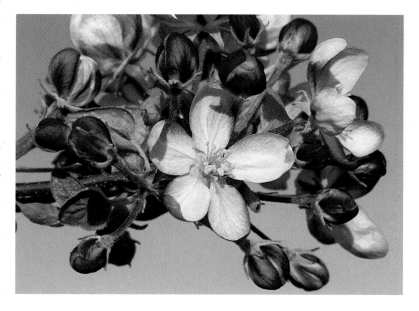

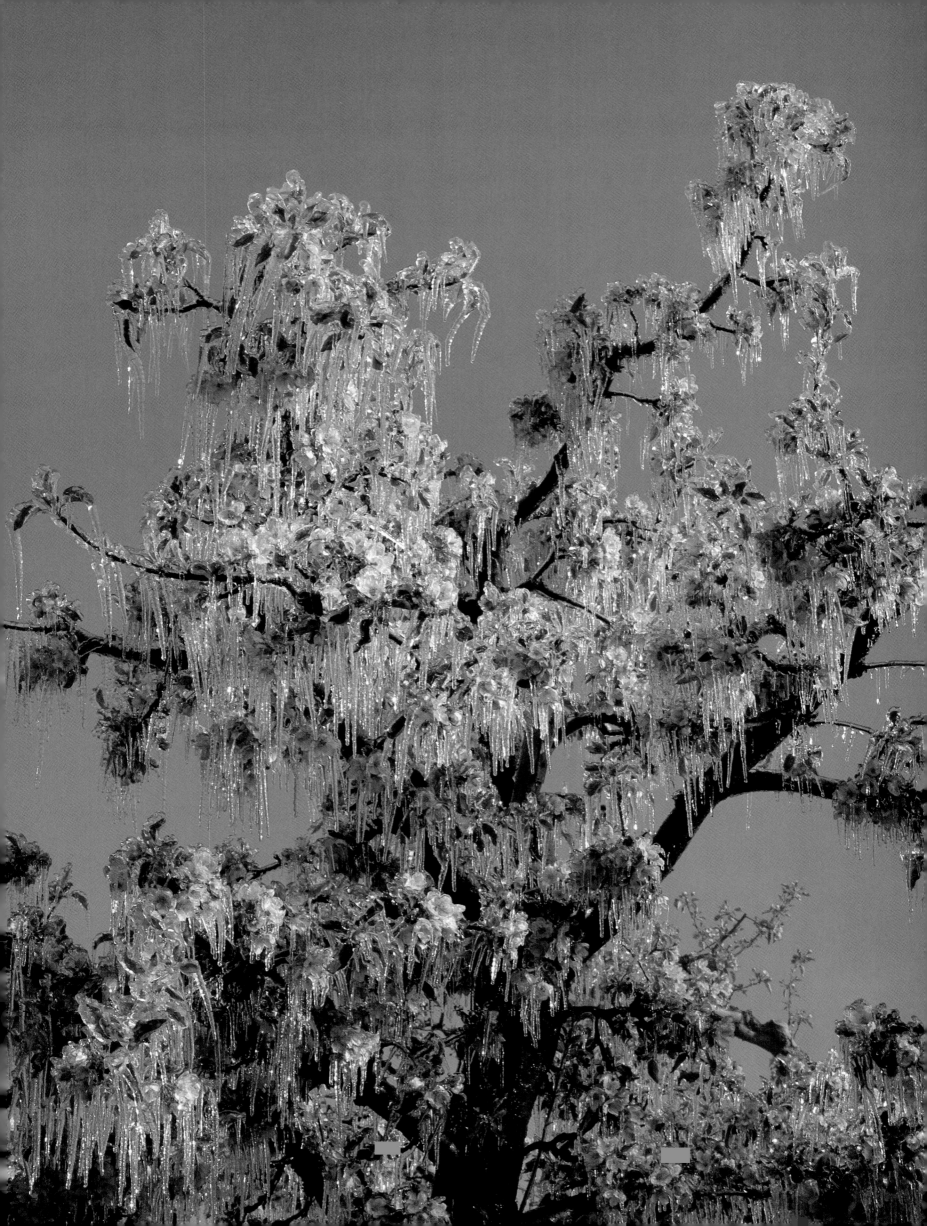

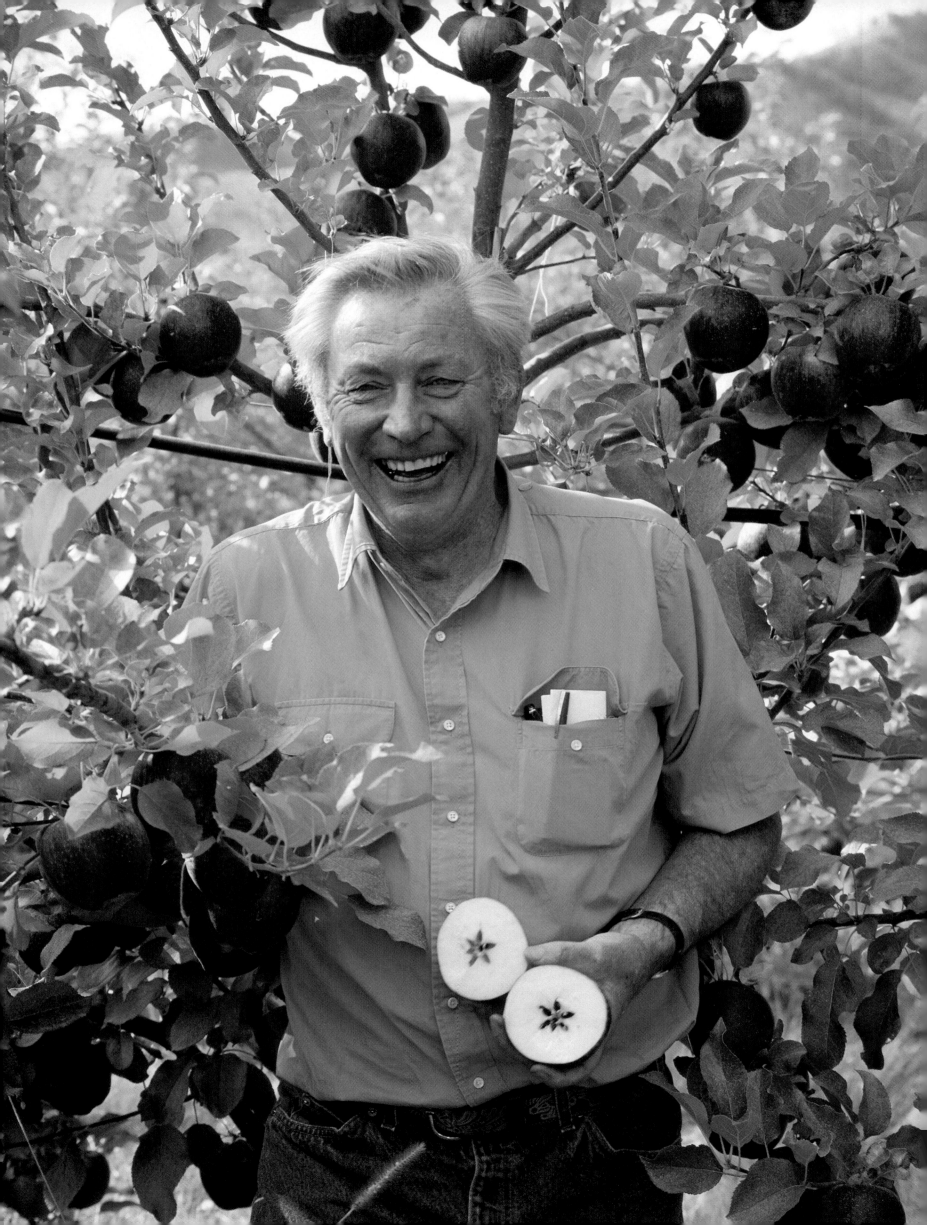

applied with a tractor-pulled airblast sprayer, or by air, usually by helicopter. Fieldmen advise farmers when the controls should be applied. Fieldmen are employed by farm chemical suppliers, private warehouses, or cooperatives that pack and store the growers' fruit, or they may work as independent consultants. A great many Washington growers hold agricultural college degrees and are qualified to monitor pests in their own orchards and act as their own fieldmen. Their objective is to use as few chemicals as possible, in the smallest amount possible, to achieve control. The chemicals are costly, and growers do not want to use any more than they have to. They are aided by Washington's ideal low pest population climate. As a result, pesticide use in Washington Apple Country is lower than in any other commercial fruit growing area in the world. Strict government regulations govern safe usage of those dangerous chemicals that are used.

Some sprays used during bloom time are chemical thinning agents. These are used during or just after bloom to increase the apple drop that normally occurs about six weeks into the growing season. Some chemicals have a caustic effect—similar in toxicity to vinegar—that results in an immediate burning of the flowers, thus allowing growers to better gauge the efficiency of the spray. Growers need to thin many apples off their trees to improve the size and quality of those allowed to mature. The process also prevents biennial bearing, which would result in too many apples being produced one year, followed by a year of too few apples.

Even with chemical thinning, trees usually need to be hand-thinned once the fruit grows to about the size of a U.S. quarter. Workers snap smaller fruitlets off the trees, leaving the remaining

◁ *Key to Washington's success in the global fruit industry are the many highly trained horticulturists who advise growers for packing houses and farm chemical companies, and through independent firms. People like Fred Valentine, a well-known fieldman for the Wells & Wade Fruit Company, help growers determine when and how pests should be controlled, when fruit needs to be picked, and how it can best be handled. The Carousel apple, which Valentine is holding, is derived from a chance seedling, but it could be an apple of note in the future.*
▽ *Red Delicious (foreground) is still king in Washington, but Fuji (background) has been a strong challenger in recent years.*

fruit spaced about six inches apart. Care must be taken not to bruise the fruit left on the tree. Thinning, along with pruning and harvesting, make up the bulk of the grower's labor expenses.

By late summer, as the limbs of larger trees become heavy with fruit, they must be propped up to keep them from breaking or dragging on the ground. Trellised trees are already held in position by wires or poles, so the additional expense of the work of propping is avoided.

A new summer expense in some orchards is bagging. Many Fuji apple growers are experimenting with placing a double paper bag over each apple on the tree to protect the fruit from insects and weather factors, and to filter sunlight. The bags are widely used in Japan, the Fuji's native country. By following this practice, the growers hope to capture a premium market with blemish-free, perfectly colored fruit to pay back the high labor cost of placing the bags on each apple, then removing them one layer at a time, during the month before harvest.

By September, the apples begin to swell in size and to gain color. Central Washington's hot, arid days and its cool, crisp nights are perfect for producing the dark hues its Red Delicious is known for throughout the world. By the time many growers have completed their sweet cherry harvest and are busy picking their d'Anjou pears, the first apples are also nearing maturity. Many of the approximately forty thousand apple pickers needed for the main harvest are already on hand. The most popular early apple in Washington orchards today is the Gala, although other early Golden Delicious-related varieties have also been planted to fill the early harvesttime slot. The original Gala was popularized by New Zealand growers a decade ago. Recently, Washington growers have planted several strains that encompass a color range of yellow through dark red. Most require multiple pickings starting in mid-August.

Golden Delicious is normally ready to pick by about mid-September, with the Red Delicious harvest getting started a week or two later. September through October is the main harvest time, when all of Central Washington bustles with frantic activity. Some Fuji, Braeburn, and Granny Smith apples are picked until November. In September, orchardists are busy hiring their crews, training them if necessary, and updating them on the latest rules handed down by government officials.

Orchard foremen move bins out to the orchard by tractor. Workers pick the apples into canvas or nylon bags strapped to their shoulders. When filled, the bottom of the bag opens to form a chute. The apples are allowed to roll gently into the bins. Each bin holds the equivalent of twenty-five full bags of apples, about one thousand pounds of fruit. When the bins are full, the tractor driver takes them to a landing where they will later be picked up by a truck and taken to the packing house. Weather-damaged and other substandard fruit will be taken directly to a processor to be made into juice and other products.

Workers are trained to pick the fruit deep into the palm of their hand to avoid bruising it with their fingers. "Handle them as if they were eggs," growers often tell the pickers. Three-legged aluminum ladders are used to reach apples on taller trees. Most trees can be picked with a ten-foot-tall ladder or less, although fourteen-foot ladders were not uncommon a few decades ago. Some new orchards can be picked from the ground. Workers are

generally able to pick Red and Golden Delicious and Granny Smith apples in one passing. Pickers have to use more judgment with new varieties, however, picking only the mature fruit on the tree and leaving the rest for a second or third harvest.

Once the apples are hauled to the packing house—usually by flatbed truck or trailers called straddle carriers that can smoothly transport a dozen or more bins at a time—they are given a quick rinse, then put away in cold storage. Later, each bin is segregated by fruit variety, quality, and maturity and distributed to an appropriate storage regime. Some apples are packed right away for immediate sales. Others are kept in cold storage for sale within the next few months. More than half of the apples are put away into controlled-atmosphere storage, where they are "put to sleep" for much later sales. The low-oxygen storage will keep the apples crisp and tasty for as long as a year.

The fruit is washed, waxed, sorted, and graded to U.S. and Washington standards, and packed in half or full forty-two-pound cardboard boxes shortly before it is ready to be marketed. Cull fruit is diverted to processors. Trucks carry 90 percent of the fresh packed fruit to markets all across the country and to Canada and Mexico. The fruit is also trucked to Seattle and California seaports for shipping to offshore destinations. An average of 330 one-thousand-box truckloads leave state warehouses every working day of the year.

Irrigation

Take a drive into Central Washington's wide Columbia Basin south of Vantage, down the Columbia River toward the desolate trailer town of Beverly, and find a dry, dusty world. From a car window, it appears to be an area filled with sand, sagebrush, volcanic rock, and little else—an uninviting land, offering few promises for the future. The view is not much different from what pioneers would have seen before the turn of the century at areas that are now Walla Walla, Pasco, Yakima, Wenatchee, and Okanogan. But instead of moving on, they stayed. They saw a parched but rich land just waiting for a drink—a land with deep volcanic soils and flood deposits that could produce some of the best crops and highest yields known to man—if only water could be distributed from the powerful rivers that sped past.

The Columbia Basin is now Washington's fastest growing orchard area. Only competition for available water rights keeps growth from exploding beyond the industry's ability to handle bigger crops. Between wide areas of desert are many of the state's largest apple and soft fruit orchards, most of them no more than a few years old and using the most modern growing methods. The basin's transformation is made possible by drawing water from the Columbia River or by digging deep wells, and in some areas with irrigation water from the Columbia Basin Project. Private reservoirs store water for those periods of time when the orchards' needs outstrip pumping ability. Today's growers have turned to drip irrigation, frugal undertree and suspended misters, and a wide assortment of water conservation methods to nourish trees and fruit without waste.

The fruit industry's early history, however, is based not so much on water *conservation*, but on water *distribution*. Thanks to the Columbia River and its tributaries, water was not in short supply. However, getting water to the land for orchard expansion was a big problem then, and it continues to be a challenge today. The region's history can be told with a look at the large irrigation projects that offer low-cost water for many farmers.

Washington Territory's first irrigation venture probably took place in 1818 at Fort Nez Perce, near Walla Walla. The Hudson's Bay Company dug a ditch to transport water to vegetables grown for the fort's residents. Not until many years later was irrigation used for wide-scale orcharding. The move toward a commercial orchard industry did not develop until around the turn of the century, and with it important irrigation projects were built, including the Gunn-Shotwell Ditch and the Highline Canal in Wenatchee, the Selah and Moxee and Sunnyside Canals in the Yakima Valley, and the West Okanogan and Whitestone projects in Okanogan County.

A scenic walk today along the Wenatchee River Valley's Highline Canal is a lesson in the state's orchard history. The canal service roads are not open to the public, but most residents have risked a scolding in order to stroll along the gushing waterways and survey the striking contrast between man's agrarian grids and nature's sloping flanks. The views are especially sumptuous in the early spring, when the rolling hills of pear and apple orchards are white with blossoms, filled like a giant bowl of popcorn.

Construction of the Highline Canal began in 1902, a few years after completion of the Gunn-Shotwell Ditch, which runs lower, near the valley floor. Promoters of the plan went to W. T. Clark, who had recently completed the twenty-six-mile Selah and Moxee Canals in the Yakima Valley. Clark sent engineers to

▽ *Apples are picked into large bags slung over a worker's shoulder and then transferred to bins, each of which holds approximately twenty-five hundred pieces of fruit. The bins are stacked for transport by a straddle carrier or truck to the warehouse, where they will be packed and stored until shipment.* ▷ *Dena Saedi picks Red Delicious apples at the John Pickens orchard near Manson. At the peak of the harvest, in late September and early October, more than forty thousand workers pick the crop. The harvest runs from late August through November. More than eighty million boxes of apples are picked annually for sale and distribution worldwide.*

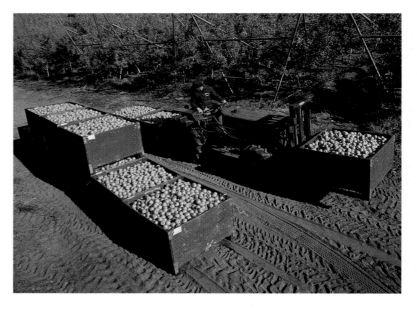

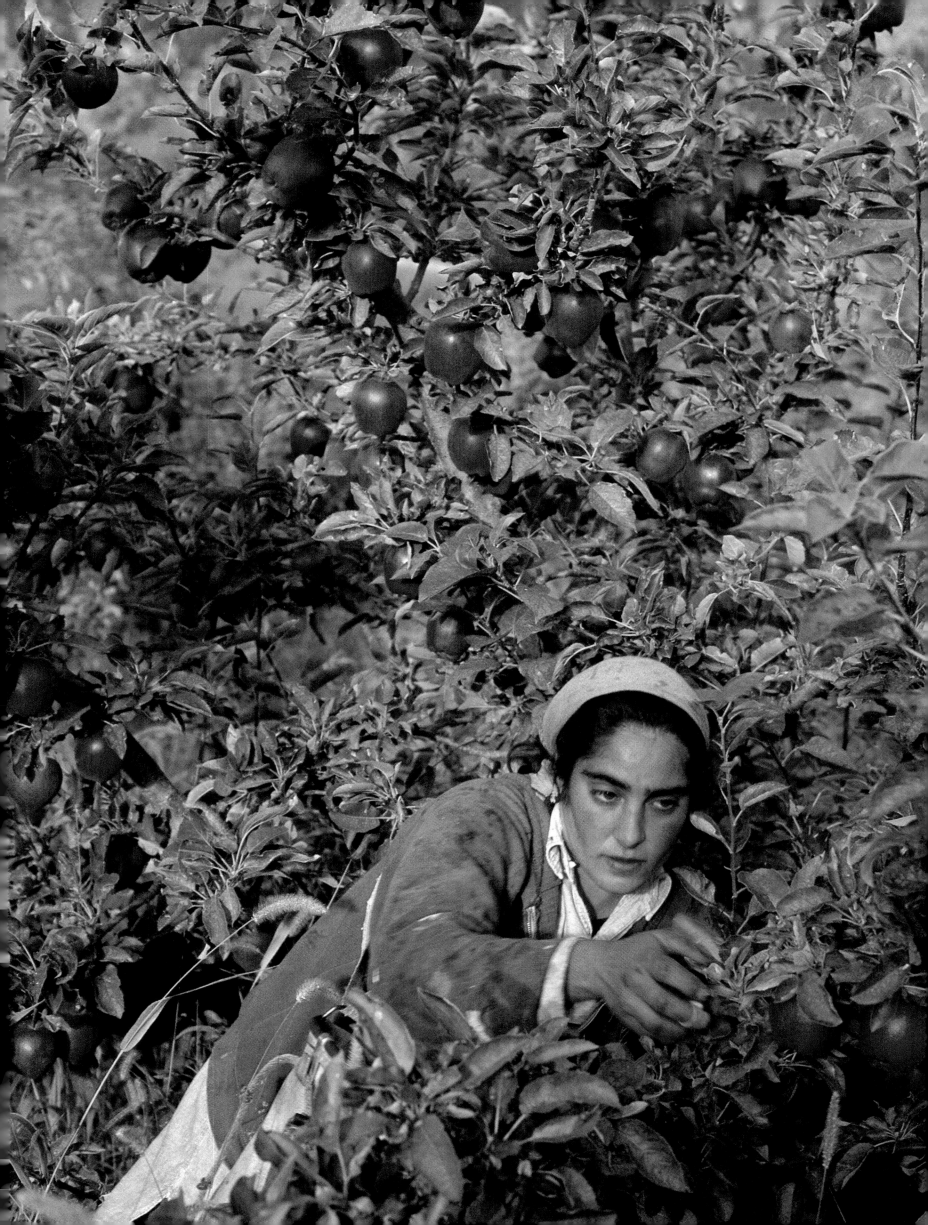

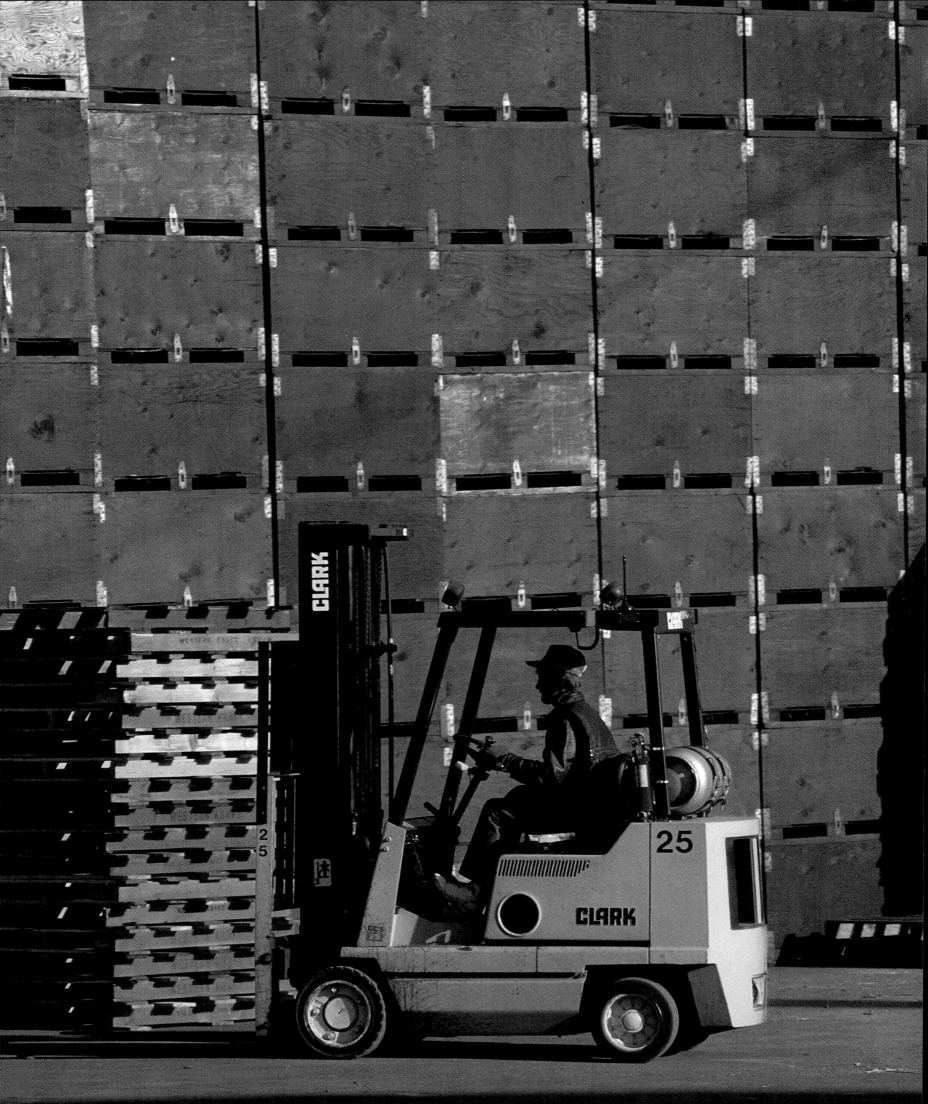

survey the land. They approved, and Clark found financing to begin the project the next year. In spite of financial, political, and technical difficulties—a number of rail cars of wooden pipe staves was lost on a siding in Utah for several months—hand labor and horse-drawn scrapers and wagons completed the canal in just two years. Today, gravity-sped water gushes through more than fifty miles of canal, from the Wenatchee River at Dryden to Wenatchee, across the Columbia River to East Wenatchee, and back into the Columbia at Rock Island. Along the way, it provides water to thousands of acres of some of the nation's best pear, apple, and sweet cherry orchard land.

On the other side of the narrow Wenatchee River Valley from the Highline Canal is the Peshastin Canal. More than one hundred years ago, O. C. McManus took shovel to dirt to dig that canal, then helped find financing to extend it to other growers in the valley. Today, his great-grandson, Scott McManus, still grows apples and pears in the area, serves on a small irrigation district board and is also a member of the board for the Chelan County Conservation District. He is concerned that growers may soon have to take new measures to preserve their valuable water supply. He believes valley canals may one day have to be converted to closed systems to cut down on evaporation loss.

"Irrigation is what makes the whole thing work," said McManus, a lanky forty-year-old who returned to the family ranch in Cashmere more than a decade ago after earning a degree in zoology, and then tiring of urban life. His education and other experiences have made him sensitive to the need for conservative water use. "We're not the only players anymore.

◁ More than two hundred warehouses are centers for packing, storing, and marketing the fruit for Washington's apple growers. Some, like Blue Star Growers in Cashmere, are cooperatives that are owned and operated by the growers themselves; others are independent businesses that provide services to growers. ▽ Orchards and warehouses are the principal employers and provide the foundation of the area economy for dozens of small communities like Monitor. The apple industry employs thousands of workers—ranging from growers, fieldmen, and scientists to pickers, sorters, and packers—and returns millions of dollars to the region's towns.

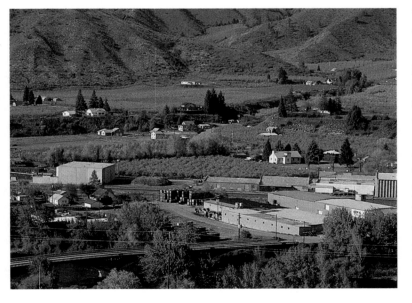

Urban use, recreational use, and instream flows are all things we need to address. As irrigators, we need to upgrade our systems."

Construction of the Yakima Valley's first irrigation canal is credited to a Native American. Chief Kamiakin of the Yakima tribe built a ditch near Ahtanum Mission, south of Yakima. The project was extended to become the Sunnyside Canal in 1889 and was completed in 1902. In 1905, it was taken over by the newly formed U.S. Bureau of Reclamation, which later constructed the Wapato, Tieton, and Roza irrigation projects. Six reservoirs, also built by the Bureau of Reclamation in the Cascade Mountains, feed the canals. After two years of severe drought in 1993 and 1994, Yakima growers and water managers are also concerned about how to conserve their most valuable resource.

Walt Van Gundy, manager for the Roza District, stood on the banks of a wide, but nearly empty, canal that supplies seventeen hundred growers between Yakima and Sunnyside. "These are critically low levels, the lowest we've ever faced," he said during the 1994 irrigation season. Charlie de la Chapelle Jr., a Yakima Valley resident who farms with his father in the Roza District, has excavated several holding ponds in recent years. The ponds enable him to store several weeks' worth of water for his orchards, most of which are watered with drip irrigation systems. He also sacrificed several acres of older trees that will be pulled out this year to make room for new trees. "We'll replant with hopes that things will be better next year," de la Chapelle said. Added Van Gundy, "We're all learning to get by on less."

The Columbia Basin, including prime orchard and row crop land that stretches between Quincy and Royal City and south to Pasco, receives water from the Columbia Basin Project, which was established after the construction of the Grand Coulee Dam in the 1940s. Extension of the project to the western parts of the basin, where industry entrepreneurs continue to have to find their own water supplies, is still on hold due to increasing demands on the water for power and environmental uses.

Apple Men

Approaching age ninety, Grady Auvil still ventures into his orchards each day just to make sure things are being done right. You will find him out grafting old trees in the spring, checking irrigation in the summer, inspecting the crop in the fall. In the winter, you may find him in the hot house that adjoins his house overlooking orchards and the Columbia River near Orondo.

"We try to do a little better job," said the industry's reigning grand old man of apples, of the fastidious and innovative nature that has made his company one of the nation's most successful small orchards. "We put more into it. We've worked at it for more than fifty years. I don't think about much of anything else."

Auvil is the often-celebrated star of Washington's fruit industry for good reason. He was a founding member of the Washington Tree Fruit Research Commission thirty-five years ago. He found his first success in the 1950s with Red Haven peaches. In 1960, he introduced Redgold nectarines to the state. In the 1970s, it was the Rainier cherry. He pioneered production of the Granny Smith apple in that same decade. It is now Washington's third-leading apple, although soon to be eclipsed by another Auvil innovation, the Fuji.

"The big one is going to be the Fuji. It's just so clear," said the apple sage, his baseball-capped, round head cocked to the side in a note of seriousness. Auvil, president of the Washington State Horticultural Association in 1953, went before fifteen hundred fruit growers at the group's annual convention in 1989 and told them the Fuji would one day replace the Red Delicious at the state's number one apple.

"The Red Delicious is dead, although it may take twenty years to bury it," said Auvil, issuing one of his many opinions— opinions that have in the past steered the industry in new directions. He believes the industry has, in the Fuji, an apple that will find favor with consumers and will store better for more reliable marketing twelve months of the year. Auvil may or may not be right on that one. Although the state's Fuji production has doubled each year since the eighty-fifth annual convention, other industry giants like Bill Evans and John Borton of Yakima, Bill Zirkle of Selah, and Ralph Broetje of Prescott continue to plant large tracts of the latest strains of Red Delicious on virgin ground.

Broetje, an orchardist who strayed from traditional growing areas to plant a sea of trees where before there was nothing, even built his own town to house workers. Like Auvil, he has planted plenty of Fuji in recent years, and Granny Smith before that.

Others are more loyal to the Red Delicious, an apple they believe grows better in Washington Apple Country than anywhere else in the world. "Grow what you can grow best," said Borton, whose third-generation family operation, Borton & Sons, farms close to two thousand acres of mainly reds near Yakima and the Columbia Basin. Although the Fuji is undoubtedly a variety that will make its mark on the apple industry of Washington, the Red Delicious will continue to be number one, Borton and many other top growers believe. Growers, researchers, and quality-control officials have had forty years to develop the red to its highest standards. It is the one apple that grows in Washington better than it does anywhere else, adds Bill Zirkle of Zirkle Fruit Company in Selah. Zirkle knows because, over the last three generations, his family helped shape the Red Delicious industry in the Yakima Valley.

"The Red Delicious is our flagship. It's the golden goose and has laid a lot of golden eggs. It's worthy of being protected," said Zirkle during a 1995 talk in support of even higher grading standards to make sure that nothing but the best apples reach consumers. Tough grading standards are nothing new to the industry. One of the early giants of the industry, James S. Crutchfield, etched the necessity for highest quality in stone nearly ninety years ago.

"You're three thousand miles from the market. There's no place in your business for anything but the finest quality," Crutchfield reportedly told Washington fruit growers just after the turn of the century. Washington's orchard industry exploded between 1904 and 1914. More than one million trees were planted in 1908 alone, and by 1910 the state was producing close to six million boxes of apples, according to historian John Fahey in his book, *The Inland Empire*. By 1930, shipments had increased to more than thirty-two million boxes, largely due to the efforts of men who pioneered ways to store, ship, and market a perishable crop around the world.

Crutchfield, a vociferous entrepreneur from Pittsburgh, Pennsylvania, hired W. F. Gwin to manage fruit marketing and shipping in the Wenatchee area. Gwin encouraged growers to form associations that would establish a degree of uniformity. Gwin later broke away to form his own marketing organization, Gwin, White and Prince. In 1919, Crutchfield went on to form American Fruit Growers, Inc. The company became one of Washington's first and largest commercial orchard enterprises, with nearly fifteen thousand acres of orchard in the Wenatchee and Yakima Valleys. Crutchfield sold his Blue Goose brand apples through the hundreds of retail outlets he also owned in the eastern United States.

In North Central Washington, Conrad Rose and J. M. Wade were important shipping pioneers. Rose owned large orchard blocks around Wenatchee in the early 1900s. He offered local farmers supplies through his grain, feed, and hardware store and was the area's first cash fruit buyer. He was responsible for shipping the first boxcar load of fruit from the area in 1908.

Wade got his start at a young age, selling milk door to door as a seven-year-old in Tennessee. He moved up to selling farm produce and found his way to Wenatchee in his early twenties on a break during his freshman year at Brown University, according to a personal history. He did so well selling apples that he decided to stay in Washington. He formed Wells & Wade Inc. with A. Z. Wells in 1915 and later the J. M. Wade Fruit Company. He later bought out the Wenatchee Produce Company, Conrad Rose's marketing empire of the previous generation, and the huge B & O Orchards in Okanogan County.

▽ *Controlled-atmosphere storage, first developed in the 1950s, has turned Washington's apple harvest into a year-round marketing industry. Nitrogen membrane systems extract nitrogen from the air and then pump it into the storage building to slow fruit respiration and keep it fresh. The fruit is kept just above freezing.* ▷ *Designers continually improve packing line efficiency to keep up with the demands of an industry on the forefront of change. Every orchard once had its own fruit storage warehouse. Today, even the largest warehouses are joining forces to gain more marketing clout and keep up with the high cost of new storage and packing technology.*

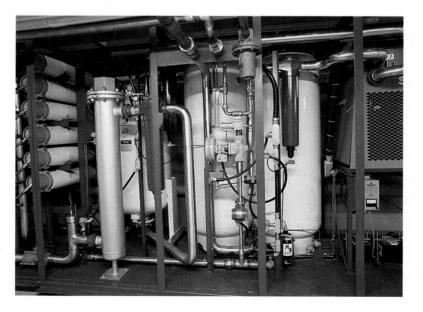

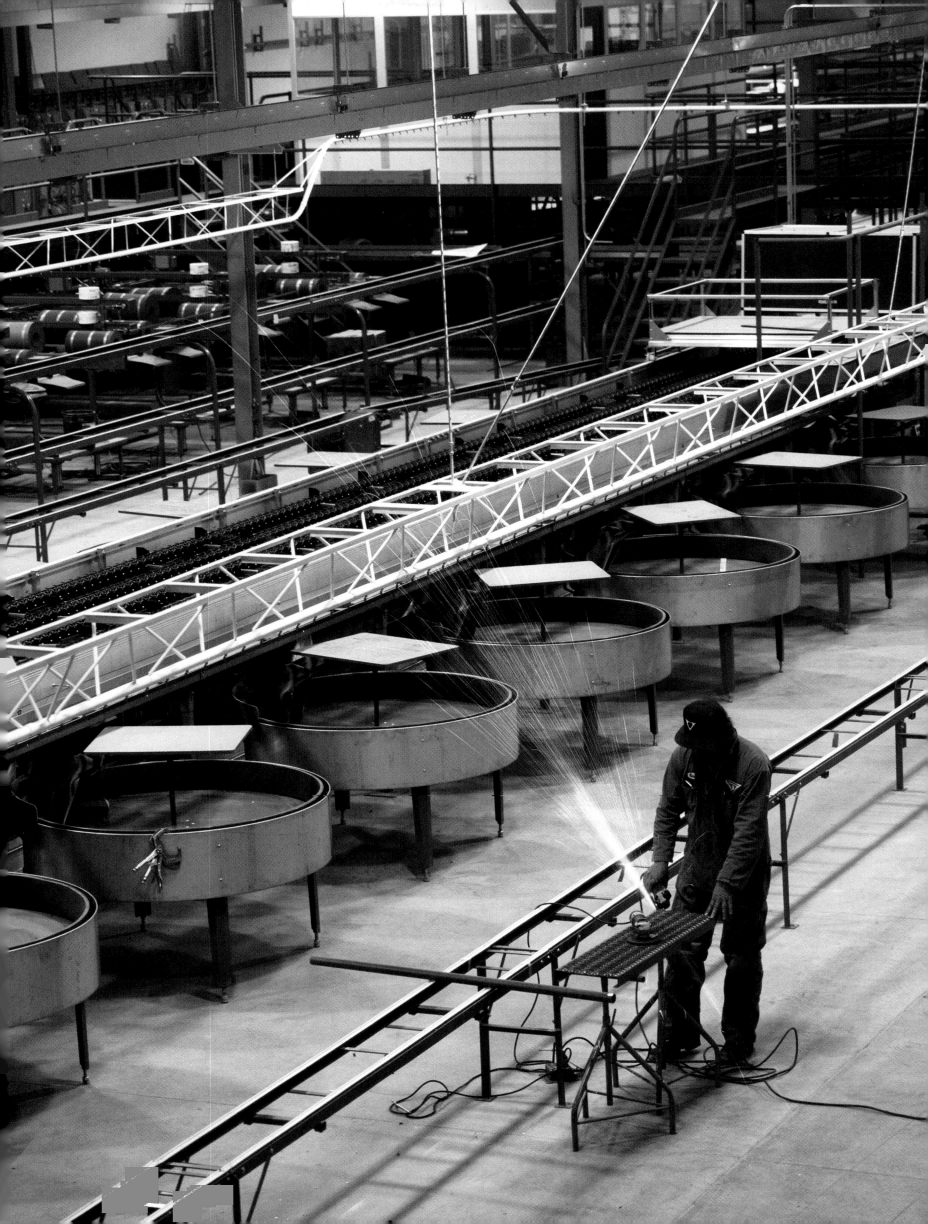

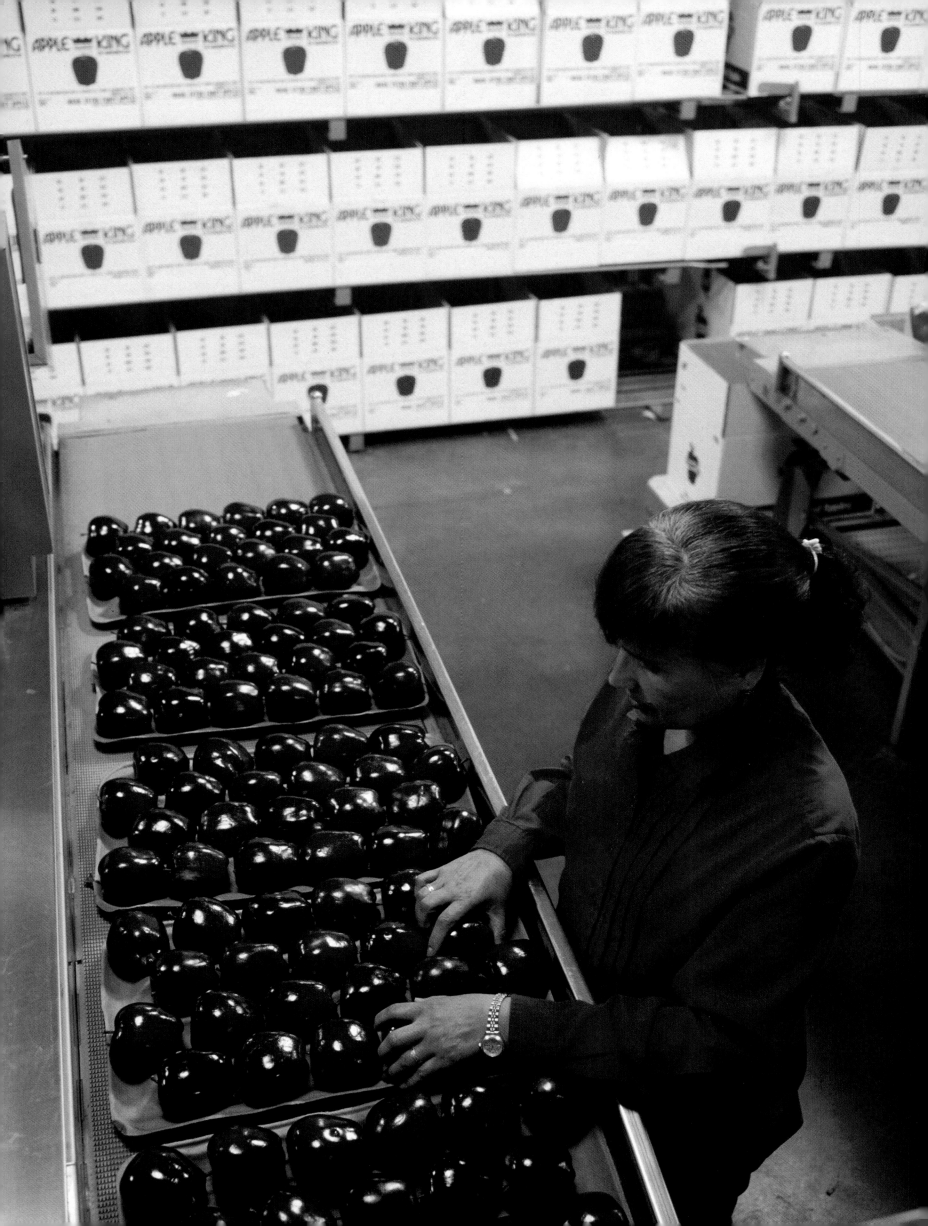

J. H. Robbins is an important name in Yakima Valley fruit marketing history. Robbins first managed the Yakima Fruit Growers Association, formed in 1910 to help growers market their fruit. He later helped form Pacific Northwest Fruit Distributors, representing some eight thousand growers in South Central Washington, Oregon, and Idaho.

The Northwest fruit empire was built on the backs of others besides growers and marketers. Researchers like Fred Overly and Jack Batjer, early leaders at Washington State University's Tree Fruit Research Center and the USDA Tree Fruit Research Laboratory, determined the shape orchards would take for years to come. Scientists like Archie Van Doren developed controlled-atmosphere storage to extend the length of time fruit could be stored and marketed. After retirement as a public researcher, Van Doren started his own fruit packing equipment company, designing much of the machinery that handles post-harvest fruit today.

Farm advisors like W. A. "Bill" Luce communicated information between researchers and growers. Until his death at age ninety-seven in 1993, Luce was one of the industry's most vibrant educators and leaders. A graduate of Massachusetts Agricultural College, Luce came west in 1920 and found work at Birchmont Orchards in Sunnyslope, then owned by the huge American Fruit Company. He worked as a horticulturist in both the private and public sectors until 1942, when he took a job as WSU extension agent in Yakima. There, he helped start the Yakima Pomological Club, and later, after working with Paul Larson on dwarf rootstock research, the Northwest Dwarf Tree Association. In 1972, Luce wrote *A Brief History of the Washington State Fruit History*.

◁ *Maria Quintero packs Red Delicious apples at the Northwestern Fruit Company in Yakima. Modern machinery automatically sorts the apples for size and color and places them into protective paper trays. Packers then load the trays into boxes. The apples will be kept in cold storage until they are ready for shipment—to anywhere from Seattle to Tokyo, Los Angeles to New York. ▽ Sorters, like Johnnie Ham at the Cascadian Fruit Shippers in Wenatchee, remove cosmetically imperfect apples from the packing line. Ham, who helped put her two daughters through college working on the sorting line, has worked for Cascadian for more than thirty years.*

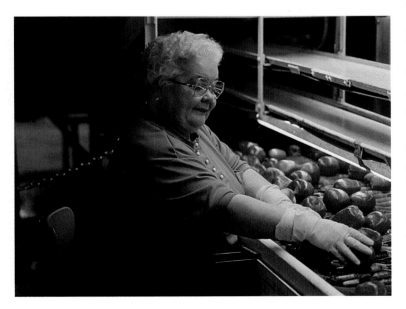

Washington Red Delicious

Even inspired imagination and the gift of foresight could not have given early settlers of Eastern Washington a full realization of the huge industry they started with the first apple plantings in the mid-1800s. The first apple tree planted in the Northwest was actually in Southwestern, not Eastern Washington. The tree, planted at Fort Vancouver in 1826 by an employee of Hudson's Bay Company, still stands. In 1971, a freeway was rerouted to protect it.

Hiram F. "Okanogan" Smith is largely credited for planting Central Washington's first apple trees in 1848, although some accounts say Smith did not plant his main Oroville orchard until as late as 1865. Smith was a territorial legislator and may have picked up trees for the orchard from a nursery in Olympia. One of the huge old trees planted near the Canadian border is said to have produced 112 boxes of apples in 1948, when it was one hundred years old.

Yakima's first apple trees were planted sometime between 1857 and 1869 in the Ahtanum Valley. One of the first horticulturists in that area was "Klickitat Peter," a Yakima Indian and one of the original owners of the Yakima Valley before it was traded off to white settlers. Peter bought trees at a nursery near White Salmon for $2.50 a dozen and planted them near White Swan close to Fort Simcoe in 1877. The first commercial orchard in the state was probably one planted in 1861 in the Walla Walla area by Phillip Ritz for U.S. Gillian Orchard. In the Wenatchee area, the earliest commercial orchard was planted by Phillip Miller in 1880. The first nursery in the state was set out in Olympia in 1854 by R. Brown, who, just five years later, established another nursery in Walla Walla.

The Columbia & Okanogan Nursery was founded in Wenatchee in 1906 by Andy Gossman, a Minnesotan who later convinced his nephew, J. A. "Bert" Snyder, to come out west from Iowa and join the business. The C & O Nursery is still operated by third-generation members of the family.

From the outset, growers were interested in planting an apple that had a long storage life and could be transported long distances without deterioration. Although settlers brought with them many varieties, time eliminated those that would not keep, said Len Wooten, a retired extension agent for Washington State University, whose grandfather had homesteaded land north of Lake Chelan.

"Settlers learned early if you could get water on the land it would grow fruit," said Wooten, still an energetic man in his eighties who has offered his horticultural expertise to several countries around the world as a private consultant. Rock-hard varieties like Black Ben Davis and Winesap were the norm. Softer apples would be left a puddle of apple sauce after storage and then an arduous cross-country journey or a trip around Cape Horn by clipper ship.

Winesap was the state's leading variety into the 1940s, but even by 1920 standard Delicious was an up-and-coming choice for growers planting their orchards. Jonathan and Rome were also popular varieties in the early years, but a third of the 1920 harvest was made up of miscellaneous varieties. By 1940, however, growers had learned what varieties would grow and sell best.

Delicious had jumped to second place behind Winesap, while Jonathan, Rome, and other varieties together only made up about a fifth of the crop. New red strains of Delicious were coming into their own, and within the next decade, the redder, more productive strains grew to make up a quarter of the 1950 crop; standard Delicious claimed more than half of the total production; and Winesap faded to about a quarter. Golden Delicious, destined to become the state's number two apple within another ten years, made its first appearance on the crop reports that same year. By 1960, Red and Golden Delicious made up 80 percent of the crop, a percentage that has only in recent years been challenged by the success of several new varieties.

All Red Delicious apples are descendants of one tree found in 1872 in Jesse Hiatt's orchard near Peru, Iowa. Hiatt cut the chance seedling down three times, and each time it grew back. Finally, he allowed it to grow and produce fruit that is today related to one out of every four apples produced in America. Stark Brothers Nursery of Missouri discovered the apple at an apple fair in 1893 and spent an estimated 750 thousand dollars to promote the new variety. Over the years, the original strain has been improved through scientific and chance mutations.

The Golden Delicious was first grown as a seedling by A. H. Mullins of Clay County, West Virginia. Paul Stark, of the Stark Brothers Nursery, traveled to Mullins's farm in 1914 and for five thousand dollars purchased rights to propagate the tree. Golden Delicious has since become one of the world's most popular varieties and probably the most important variety grown from a seedling in the twentieth century. It has been Washington's second-leading variety for the last thirty-five years.

With the development of the Red Delicious, Washington growers had truly found an apple variety they could promote as the state apple, said Joe Brownlow, manager of the Washington Apple Commission between 1963 and 1984. Other areas grew the variety, but none could do it better than Washington, with its warm days, cool nights, and relatively few pest problems. Growers organized to pool funds and tell the world about the beautiful, large apples only Washington could produce. Although growers first gathered to discuss promotion of Northwest apples as early as 1894, it was not until 1937 that a state law was approved organizing the Washington Apple Commission and allowing the group to collect a one-cent assessment on each box of apples sold. For twenty years before that, pioneering growers' cooperatives had used voluntary assessments to pay for advertising.

Growers formed Washington State Apples, Inc. in 1935, and with support of 85 percent of the state's growers, hired one of the best promoters in the country, remembers Brownlow, who wrote a history of the Apple Commission. The J. Walter Thompson Advertising Agency designed ads for *Good Housekeeping* magazine and major newspapers across the nation. The successful promotions were very much needed to offset a tough period for the industry, as the Great Depression was for all Americans.

"This was a very dark period after the Depression," said Brownlow, a fit and trim octogenarian who lives on the edge of a golf course in East Wenatchee. C. E. Chase, a Yakima businessman who was appointed Washington State Apple's manager, used promotional tactics to revive the industry from the economic slump left by the Depression and from consumer fears about residues of lead arsenate pesticides that were then used to control apple codling moth. Horrendous pest problems forced growers to join forces and form centralized washing and packing operations. But the hot water baths that were used to wash off residues shortened the storage life of the apples. The seriousness of the problems prompted Washington Governor Clarence Martin to sign into law a bill creating the Apple Commission and mandating a one-cent assessment. Today, the Apple Commission collects a twenty-five-cent assessment on each box of apples and promotes the crop in markets worldwide with an annual budget of nearly twenty-five million dollars. Although some growers think they are required to pay too much, others believe it is only a small portion of what will be needed to promote bigger crops and greater worldwide markets in the future.

The promotion and advertising needed to succeed in marketing a world-size crop on the global market may be far more than what is currently budgeted, according to Desmond O'Rourke, an agricultural economist at Washington State University—"Maybe more like one hundred million dollars." He noted that although Washington may produce more than half the fresh apples sold in the United States, it only produces about 5 percent of the world supply. The state apple industry's future, he said, is strongly linked to doing well in emerging countries around the world.

The Apple Commission is perhaps the most important, but not the only, organization that has represented the industry. The Northwest Fruit Grower's Association was formed before the turn of the century. That group developed the fruit industry's first standardized box, which was used until the 1950s.

▽ *Less-than-perfect apples, or culls, are loaded into trailers to be sent to processors, where they are made into juice or other frozen, dried, or canned food products. Bulk juice concentrate is sold to other food companies for use as sweeteners in many foods and beverages. Dried and frozen apples are also used in a wide variety of products, including cereals, cookies, baked goods, and frozen pies.* ▷ *Tree Top Incorporated is one of the world's leading producers of fresh and frozen apple juice and other processed fruit products. The Selah, Washington-based company is owned and directed by the Washington growers themselves, who provide it with apples, pears, and other fruits.*

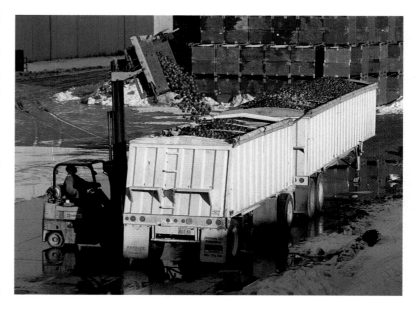

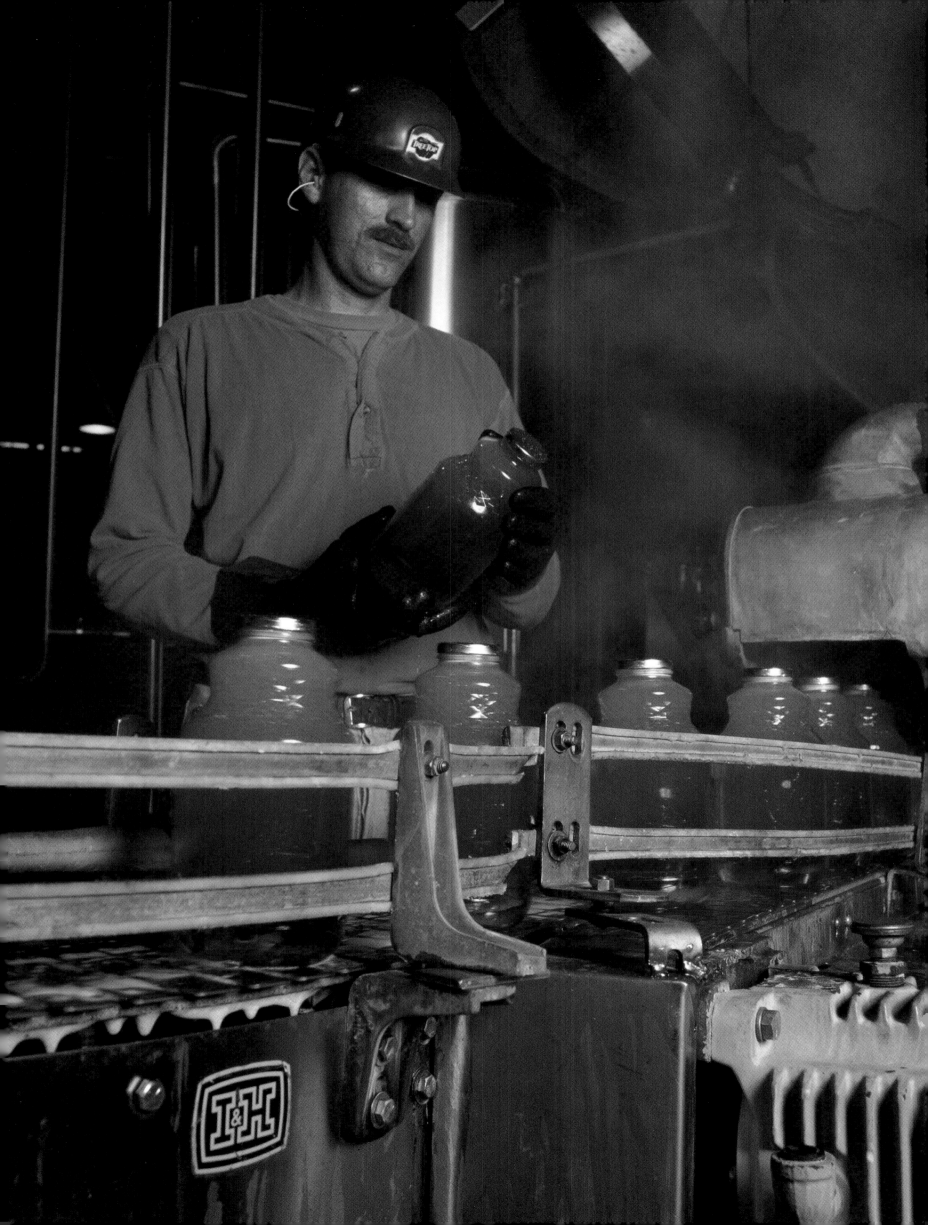

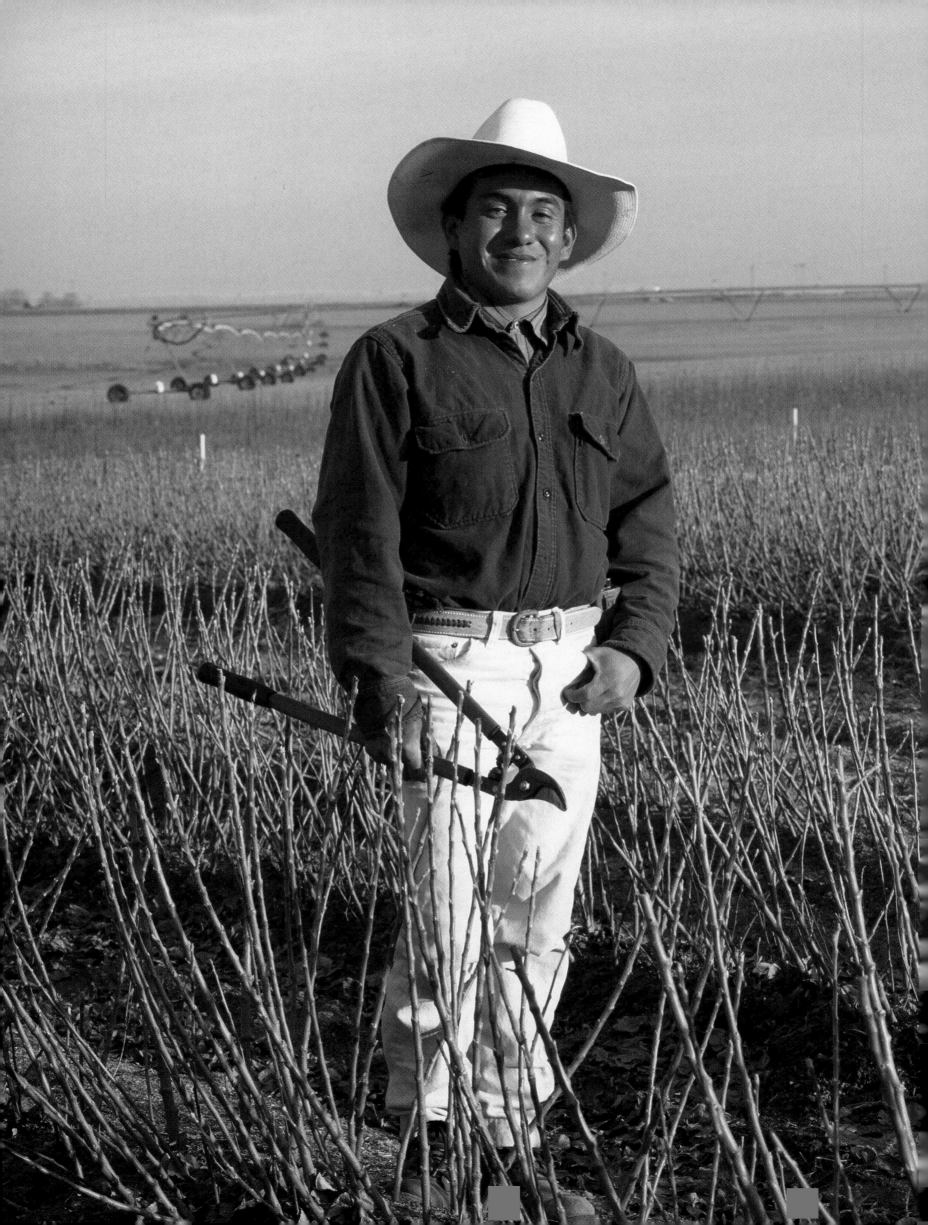

The Washington State Horticultural Association was formed in 1903. Today, with more than five thousand grower-members, the Association continues to be the industry's central organizing force. It oversees several committees, including the Washington State Apple Maturity Program, which determines when the fruit is mature enough to pick and ship, making sure only the best-quality apples reach the consumer.

The Northwest Horticultural Council was organized in 1947 to represent the industry in political and international trade matters. Other important industry organizations include the Washington State Tree Fruit Research Commission, to develop grower-oriented funds and goals for research; the Washington Growers Clearing House, to keep tabs on fruit pricing; and the Wenatchee Valley Traffic Association and the Yakima Valley Growers and Shippers Association, which keep a running account of fruit shipments and remaining supplies.

The Workers

Washington Apple Country was a land of mystery and opportunity when I made my first venture north to pick apples in 1970. At that time, most of Washington's fruit was picked by white migrants from the Southern United States. They were called Okies and Arkies—not usually to their faces except by one of their own—but they also came from Missouri, Tennessee, Texas, Arizona, Alabama, Florida, and other states. Some of them were descendants of the very migrants of whom John Steinbeck wrote in *The Grapes of Wrath*. Many had been farmers who had fled the

◁ *Heladio Viveros stands over a forest of future fruit trees near Pasco. Fruit trees begin life as rootstocks started in "stool beds," which are formed by bending saplings over and burying them in soil and wood chips. Roots form along the buried portion, and new shoots grow up, as shown here. Each shoot is chopped off and replanted. Rootstocks do not by themselves bear desirable fruit; they influence the tree's overall growth, winter hardiness, and disease resistence.* ▽ *Leaves are clipped from a twig taken from an apple tree. At each leaf node there is a bud that will be spliced onto a rootstock. The new shoot will bear fruit true to the tree from which the bud was taken.*

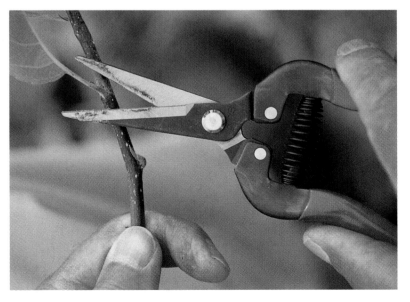

Dust Bowl that blowing winds and the Great Depression had made of the Midwest in the 1930s. Some had resettled in California and Oregon. Others stayed in Washington and eventually bought orchards.

It was a strange experience to travel north from my Northern California home to the lush orchards carved out of the Central Washington desert and find myself surrounded by stone-jawed, but sometimes toothless, people who spoke in Southern dialects I could barely understand. The men seemed stern and the women kept to themselves, but once it was clear I had come to work and not look down on them, they were happy to teach me how to make good money at a skill they had practiced for generations.

"You've come to the right place. This here is the best picking there is," said Walter Williams, a third-generation migrant from Eastland, Texas. Williams was a carpenter, a roughneck oil driller and a Pentecostal minister who regularly left Texas in the spring to pick the first sweet cherries in Central California. He, along with a half-dozen relatives—all with large families—followed the cherry harvest through California, Oregon, Washington, and then Montana, returning to Washington for the pear and apple harvest in the fall. Some winters, he traveled back to Southern California or Florida for the citrus harvest.

You could make more money faster, under better conditions, in Washington than anywhere else, he swore. Conditions were worse in the South. California was okay, but it was hard to find work. If you did, it usually did not last long because there were too many workers. Washington had the best crops and longest jobs. Farmers often treated workers like one of the family, he said.

After about four years on the fruit run, I found out for myself that Walter was right. By that time, I had picked in many of the same areas he had, often in the next row over. During that period and for the next ten years, as my wife and I and later a son, became enveloped in the migrant stream, I always looked forward to Washington as a place where the fruit was bigger, the pay sweeter, and the surroundings warmer than anywhere else.

Ostensibly, I was working on a book about migrant workers. Before I knew it, I had become one of them. What I found was a job and a lifestyle that were more than just tolerable; instead, life was often enjoyable and rich with adventure and romance. As a ragamuffin hippie schooled in art and literature, I found it easy to find value in a lifestyle that offered freedom from a punchclock, one that presented beautiful vistas and outdoor physical labor performed at my own pace. At the same time, I found myself trapped after awhile in a job that offered little beyond what was needed for day-to-day existence, a position of very low status with little hope for the future.

Many who picked cherries, pears, and apples around me were less romantic about their jobs than I, but few complained; the work was too hard for that. At piece-rate wages, you either put your mind to your work, or you left for greener pastures.

Since the 1970s, most Anglo migrants with whom I worked have left the fruit run for other opportunities. They have largely been replaced by Hispanic workers who have flooded across the Mexican border and sought the jobs with more persistence and desperation than those with wider choices before them. Growers, by and large, have welcomed the surplus of reliable, willing labor that has allowed their industry to greatly expand over the last two

decades with relative ease. In return—and also because of changing state and federal regulations—the growers have begun to offer workers more continuous work, better wages, and benefits.

Some forty to fifty thousand workers are needed at the peak of apple harvest. Add to that the thousands of apple packers—nearly all women—and other warehouse workers, truck drivers, and clerical staff. Some harvesters also work in Washington's earlier fruit crops: cherries, peaches, plums, apricots, nectarines, and pears. Others work the asparagus, grapes, and hops. In all, agriculture accounts for the state's largest area of employment, in excess of one hundred thousand jobs annually.

One of those workers is Ezequiel "Frank" Serrato, a quiet, handsome man with a thin mustache and curls of silver hair that sweat down from beneath his hard hat. Serrato moves a ten-foot aluminum ladder like an extension of his muscular body, pulling back to free its hinged tripod leg and cast it into the tree in one swift, synchronized movement. Letting it fall gently into position, he runs up the ladder's rungs to reach the dark red apples at the top of the tree. He works his way down and side to side, picking each and every one deep in the palm of his hand and laying it gently, but swiftly, into the canvas bag slung over his shoulder.

When the bag is full, he waddles back down the ladder, eases the bag over the side of the three-foot-high plywood bin and lays the bag on top of the bin's half-full volume of apples. The bag is dragged across the fruit, its contents allowed to pour out like grain. Only then does he pause briefly to chat with me as I walk through Dale and Jean Peterson's apple orchard near Manson, overlooking scenic Lake Chelan.

More eager for a break are his two teenage daughters who work with him. Also working in the orchard are two grown sons, their wives, and another daughter and her husband. Serrato, in his sixties, has eleven children, I am told by Dale Peterson. All of them, at one time or another, have worked in the orchard.

"It's important to keep a family together," said Serrato. His daughter Luisa interprets for the soft-spoken patriarch. Serrato has been making the trip between his winter home west of Mexico City to Peterson's orchard for more than thirty years. He hopes someday to retire to his cattle, horse, and donkey ranch in Michoacan. Some of the married children follow the fruit most of the year, then return to California for the winter. They are content to do orchard work but hope their children find something better. Luisa and her sister admit they would prefer to stay in one place and work a steady job.

"It's the father that keeps them coming back," said Peterson. "We just feel real fortunate to have these people and hope to have them for some time to come. They're bright. They're bilingual. They're family."

Peterson pays his pickers twelve or thirteen dollars a bin. A bin holds approximately twenty-five full bags of fruit and takes about an hour for one experienced picker to fill. Most pickers or picking couples in the orchard make more than one hundred dollars a day, Peterson said.

According to the Washington State Employment Security Department, pickers earned an average of $8.50 an hour for piece-rate work in the early 1990s. Per-bin rates ranged between six and fifteen dollars, sometimes more for apple varieties that required multiple pickings. Of about forty thousand apple harvest jobs, at least 30 percent are filled by workers who migrate from out of state. More workers are settling in the state for longer periods of time, often performing other tasks on the same orchard they harvest. Approximately 23 percent of the orchards in Washington provide housing, according to the department survey.

Many women prefer to work in packing sheds rather than out in the orchard. Eileen Deeter Harvey started work on an Omak packing line in 1942, later moving to Oroville. She saw many changes in work conditions over her more than fifty years as a packer. At Oro Fruit Company, she worked under Fred Clark, and later his grandson, Bud Clark.

"We worked a ten-hour shift, five days a week, and nine hours on Saturday. That was like a bonus, a whole hour less!" wrote Harvey in an article published in *The Wenatchee World*'s *AgWorld* magazine after her fiftieth anniversary as a packer in 1992. Conditions have greatly improved since the 1940s. Lighting was bad; the warehouse was so cold frost built up on the interior walls; and sorters had to sit with blankets wrapped around their legs. Packers were paid six cents to fill a standard forty-two-pound box. Each apple had to be hand-wrapped in tissue paper. When Harvey started work at Oro Fruit Company in 1945, there were seventeen different packing sheds in the area. Today, consolidation has reduced that number to two. The hand-pack piece-work scale gradually increased to thirty-five cents a box to place apples on cardboard or Styrofoam trays. Warehouses are now heated and well lighted. Most packing lines today are computer automated, and both sorters and packers are paid an hourly wage.

▽ *Growers do not always start from scratch when they renew an orchard. Undesired varieties can be cut to the trunk and grafted over with scionwood of a wanted variety. Scionwood is a thin, living piece of branch from a tree. The freshly cut scionwood is inserted into a narrow slit in the trunk of the mother tree.* ▷ *The art of grafting goes back to the time of the Egyptians. Several grafts are made and then sealed with grafter's wax so that moisture is held in and the plant tissues can fuse together. The resulting tree will grow the fruit of the new variety using the mature root system of the old tree, thus greatly speeding up the production of fruit in the new tree.*

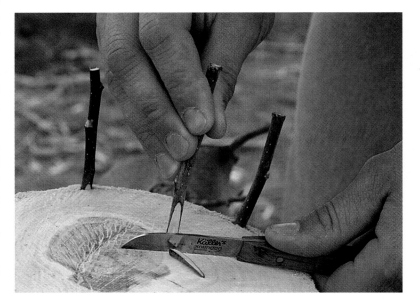

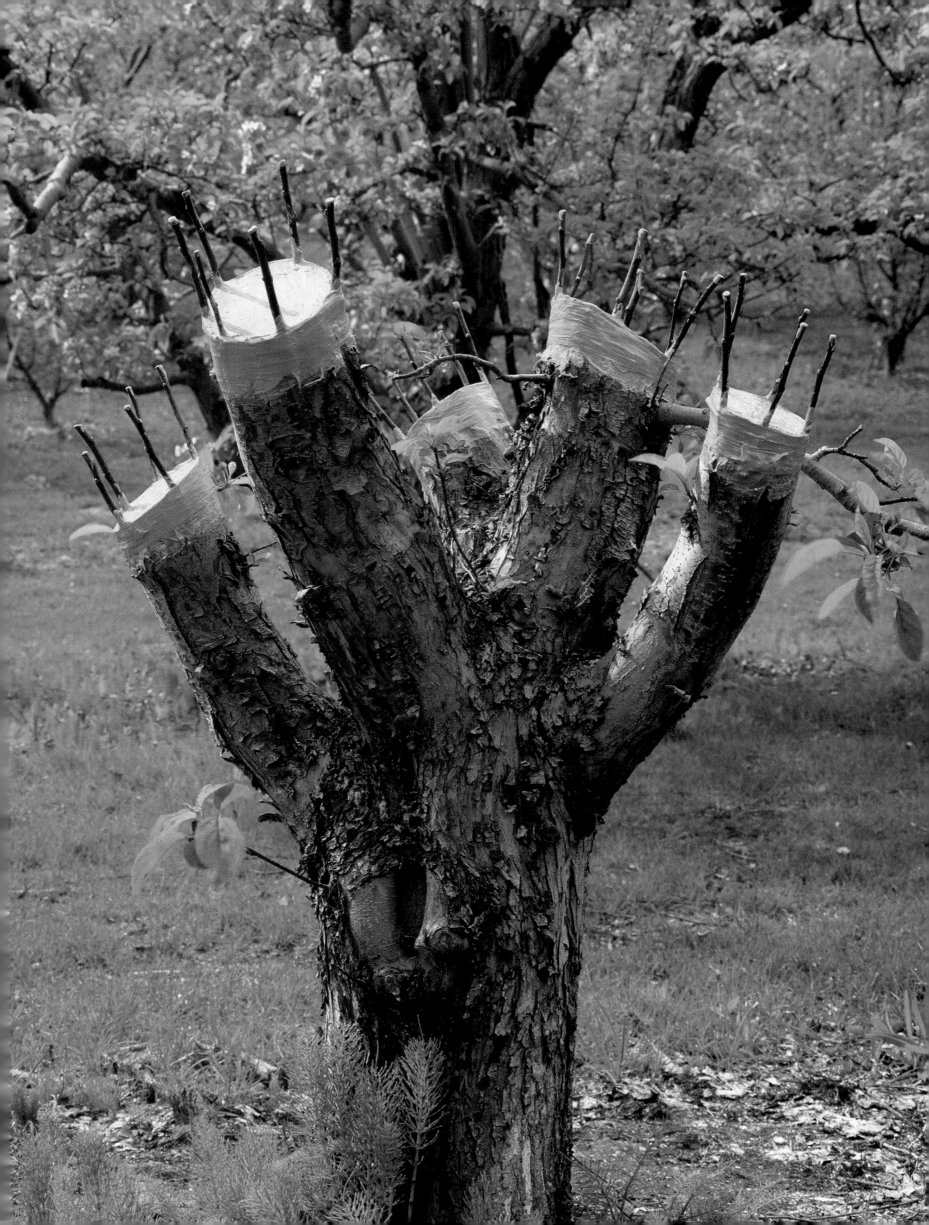

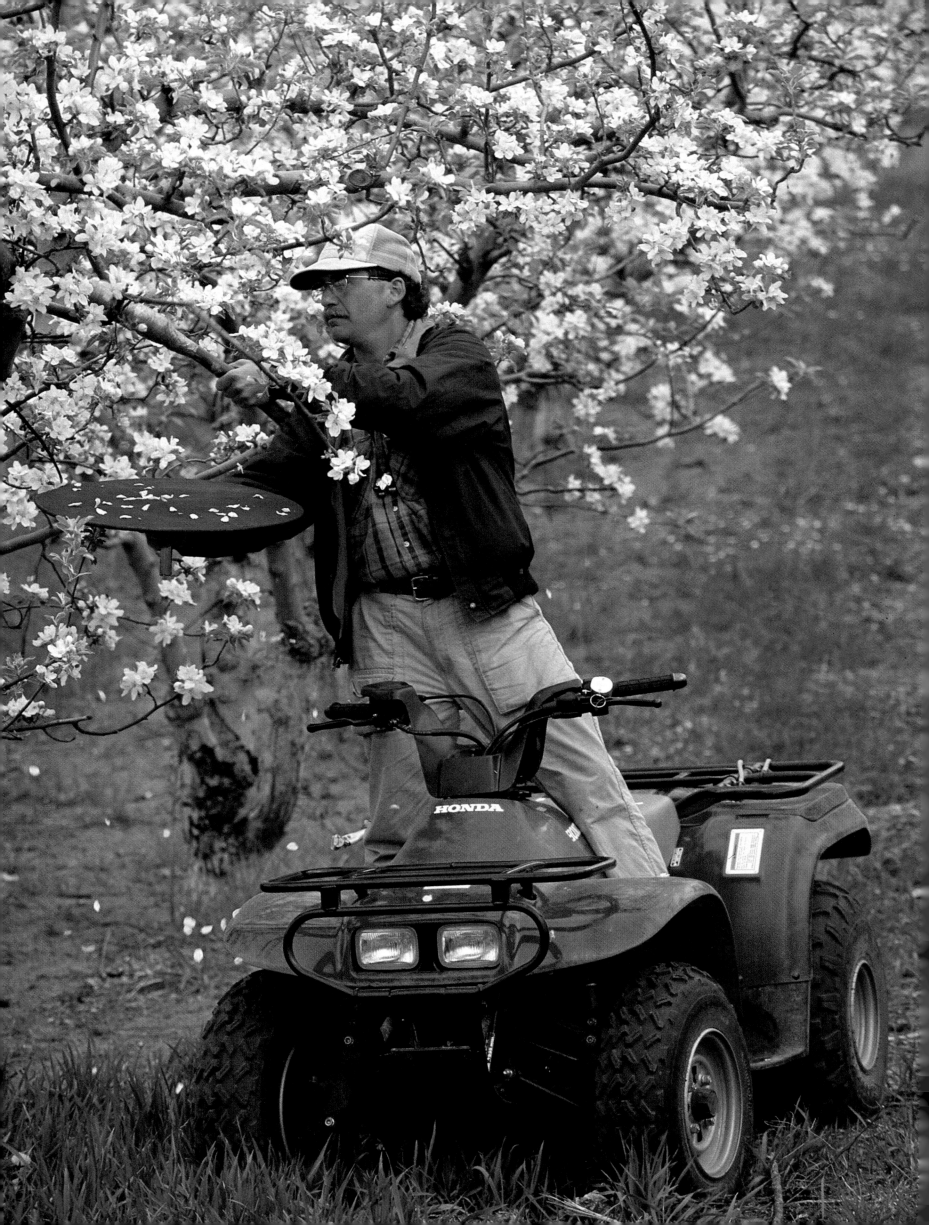

Starting her fiftieth year of packing, Harvey wrote, "From canvas bottomed bins to automatic everything, it's been fun. There have been lots of changes. I've worked with many wonderful people. I still like to pack apples—that's the bottom line."

Crisis in the Industry

February 26, 1989, was a bad day for apples. The CBS news program, *60 Minutes*, had just broadcast a segment based on a flawed scientific report that alleged the growth hormone Alar was a "potent carcinogen" when used on apples. The danger, according to the broadcast, was especially serious to children. The allegations plunged like a knife through the heart of an industry whose product is a national symbol for health and vitality. The report started an unearned roller coaster ride of negative publicity that lasted nearly two years.

Ironically, most Washington apple growers had not used Alar for two years before the broadcast. The product was used much more heavily by apple growers in other states and by Florida tomato growers. Both the Washington Apple Commission and Tree Top, the state's largest apple processor, had advised growers to stop using Alar as early as 1987 because the product had become controversial and could affect marketing. It sure did. Yet, no one has ever proven Alar to cause anyone to become ill. Moreover, millions of people were put at much greater health risk when they deleted apples and other fresh fruit and vegetables from their diets due to a paranoia over trace residues of farm chemicals that had been safely used for decades.

◁ *Integrated pest management consultant Andy Kahn taps the limb of an apple tree near Orondo to monitor for pests. Pest monitoring is an important way to determine the correct timing of pest control application, which results in greater efficiency and reduced pesticide use.* ▽ *Because of ideal climatic conditions, Washington orchardists use less pesticides than growers in any other commercial apple-producing region in the nation. A new generation of products—safer for the environment and also for consumers, growers, and farm workers—is being introduced. The products are applied with a tractor-pulled airblast sprayer, or by helicopter or fixed-wing aircraft.*

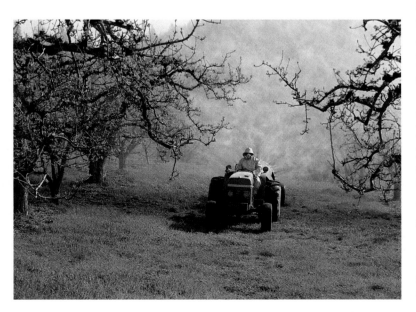

For farmers, it was just another in a long list of valuable tools lost. For twenty years, Alar had been a great and inexpensive product that made growers more money. It boosted production, made red apples redder and crisper, and allowed warehouses to store the apples longer. Under pressure from the Environmental Protection Agency, Uniroyal, Alar's manufacturer, voluntarily removed the chemical from U.S. sales in June 1989. It is still used in most of the world's other apple growing countries.

Although the *60 Minutes* report had many serious errors and was discredited in publications as diverse as *Science* magazine, *Issues in Science and Technology, The Washington Post* and *Reader's Digest,* it started a wave of consumer paranoia that stunned both Washington's and the nation's apple economy and started a volcanic upheaval in the industry that continues today. It was not the first or the worst threat the industry had suffered, nor by any means the last. Thousands of growers had been put out of business fifty years earlier by a more real fear of lead arsenate, used heavily until the 1940s to control apple codling moth.

But the period since the Alar controversy has been among the most troublesome in the industry's hundred-year history. Alar seemed to create a domino effect of economic hardships caused by growing global competition, overproduction, consumer confusion, increasing farm costs, and a barrage of new government regulations. It has been a time that has forced growers to step out of their overalls and into their business suits, a time to lay down their pruning shears and bow over their computers. Some previously successful growers have quit the business out of sheer frustration.

Through it all, the industry and most of its growers have not only survived, but have grown even stronger. Like the pests that often frustrate them, farmers just seem to get tougher and more resilient with every challenge thrown their way. Over the years they have weathered huge marketing shifts, the Great Depression, major pest invasions, bacterial epidemics, container changes that threatened to bankrupt packing houses, and two world wars.

In the fall of 1991, three well-dressed men walked briskly, single-file, like military commanders, to a podium before about fifteen hundred growers and other apple industry employees gathered in Wenatchee for the eighty-seventh Annual Meeting of the Washington State Horticultural Association. The men's demeanor was serious and stiff, poised to declare war and sound the message for troops to prepare the trenches. Robert Brody, a dapper orchardist in a silver suit that matched his silver combed-back hair and mustache, was flanked by two much taller men, one an attorney, the other a professional publicist.

Brody and ten other Washington apple growers had filed a two hundred million dollar suit against CBS and the Natural Resources Defense Council—the environmental group that first published the report—for product disparagement. The growers accused CBS of knowingly exaggerating Alar's health risks to boost its own television ratings. Only a year into the case at the time, Scott Jonsson, one of twelve attorneys representing the apple growers, said it already reminded him of a war.

"It brings to mind Pearl Harbor. A single preemptive strike that led to four years of war," said Jonsson. The report was indeed a call to arms, one of many between 1989 and 1993, when the suit was finally thrown out of federal court. The First Amendment

protected CBS's allegations—false though they may have been. Though many growers would still like to have their day in court—a possibility with the case still under appeal—most feel they have already won small victories, as bittersweet as they may be with a price tag that ran well over one million dollars in attorney fees and promotional expenses. The focus of the suit and subsequent appeal is to force media to be more responsible when dealing with farm issues, said Brody. If successful, the case would give product disparagement issues the same standing as libel issues in court. As a result, the press would be required to present more balanced reports when making charges based on questionable data. It could effectively end the reporting of 'junk science,'" he said.

Some growers, like Brody and Bert Stennes of Pateros, still suffer the recurring nightmare of the television show that cost them thousands of dollars overnight and put many of their friends through the anguish of bankruptcy. "At first the show made me furious," remembers Stennes, a semiretired orchardist whose sons now handle the Okanogan County growing and packing operation started by his father. Not until after his anger subsided did the real impact of the broadcast set in. Within a week, Washington Red Delicious prices plummeted from a healthy $13 a box to an average $6.60, about $3 *less* than what a grower spent to produce the fruit at the time. Several of Stennes's close friends were forced to sell a piece of their orchard for real estate or give up orcharding altogether. By the end of the year, losses to Washington's apple industry totaled an estimated $160 million.

"I took it personally when they called me a child killer," Stennes said of the allegations that still rile him, not because they threatened his economic well-being, but because they impugned his moral integrity. "I've been eating these apples since 1924, and I'm still in good health."

American and world consumers knew as much. They quickly forgot about the frightening report and returned their trust to the apple-eating habits that had kept them healthy for generations. The apple marketing years 1991 through 1993 were some of the most successful in recent years, bringing growers F.O.B. receipts of more than one billion dollars annually and catapulting apples to the number one agricultural product in a farming state. The transition from woe to bankroll had to do with more than just luck and consumer loyalty, however. Growers may have become angry and defensive when the report was first broadcast, but the message that consumers were concerned about farm chemical residues on their food was not lost.

Growers turned their industry around in a way that had not been done for fifty years. Older Red Delicious varieties that would not color or keep without Alar were pulled out and replaced with newer red strains or entirely new apple varieties. New, efficient orcharding systems went from the unknown to the norm within a few years. Millions of dollars were poured into research to come up with ways to reduce the use of all farm chemicals. Many of the growers tried raising apples organically. Warehouses initiated programs to reduce the use of pesticides and other chemicals.

The industry had survived once again, and according to Grady Auvil, an Orondo apple grower and one of the eleven plaintiffs in the Alar suit, some of them, himself included, made money beyond their wildest dreams—not from the lawsuit that may never reach court, but by their tenacity and willingness to change the way they grow fruit. There were many casualties, said Auvil, but for those who were willing to roll up their sleeves and learn, there have been rewards. "It's a brand new ball game," he said. "This is why the industry is first."

New Directions & New Varieties

In recent years Washington's apple industry has taken a turn away from its flagship product, the Red Delicious. Although reds are still—and may always be—the number one apple in the state, many growers have found handsome profits with new varieties that were unknown to them a decade ago. A global marketplace and consumers looking for new tastes have welcomed new apples like Fuji, Gala, Braeburn, and Jonagold. They have become the hot new apples to plant and are likely to show up on your kitchen table some day soon. New apples have been a mainstay on Doyle and Thyra Fleming's kitchen table at Bray's Landing on the Columbia River for several years.

"Here, try one of these," says Doyle, hoisting a slice of a Braeburn apple on the end of a pocketknife. The apple is very crisp, juicy, and sweet, but with a touch of tartness. Fleming eagerly slices up another apple, this time a Fuji. Extremely sweet, juicy, and potato crisp. The apples are not as pleasing to the eye as the tooth-shaped, dark Red Delicious sitting on the table, but they are sweeter to the taste. The Braeburn's taste is more complex. Both have very good storage life and may become important varieties in Washington's future. Fleming has become a leader in the race to explore new varieties and more efficient

▽ *A simple monitoring device indicates to growers and fieldmen the presence of the codling moth, the apple's worst enemy. The cardboard trap contains sex scents—known as pheromones—that attract male moths.* ▷ *As a control technique, pheromone dispensers are placed throughout the orchard. Hundreds of time-release dispensers per acre emit their synthetic sex scents to confuse the male moth looking for a mate, thus ruining chances to create a new generation. This integrated pest management technique greatly reduces the need to use toxic sprays that can also kill beneficial insects. IPM, as the technique is called, can also be used to control other pests.*

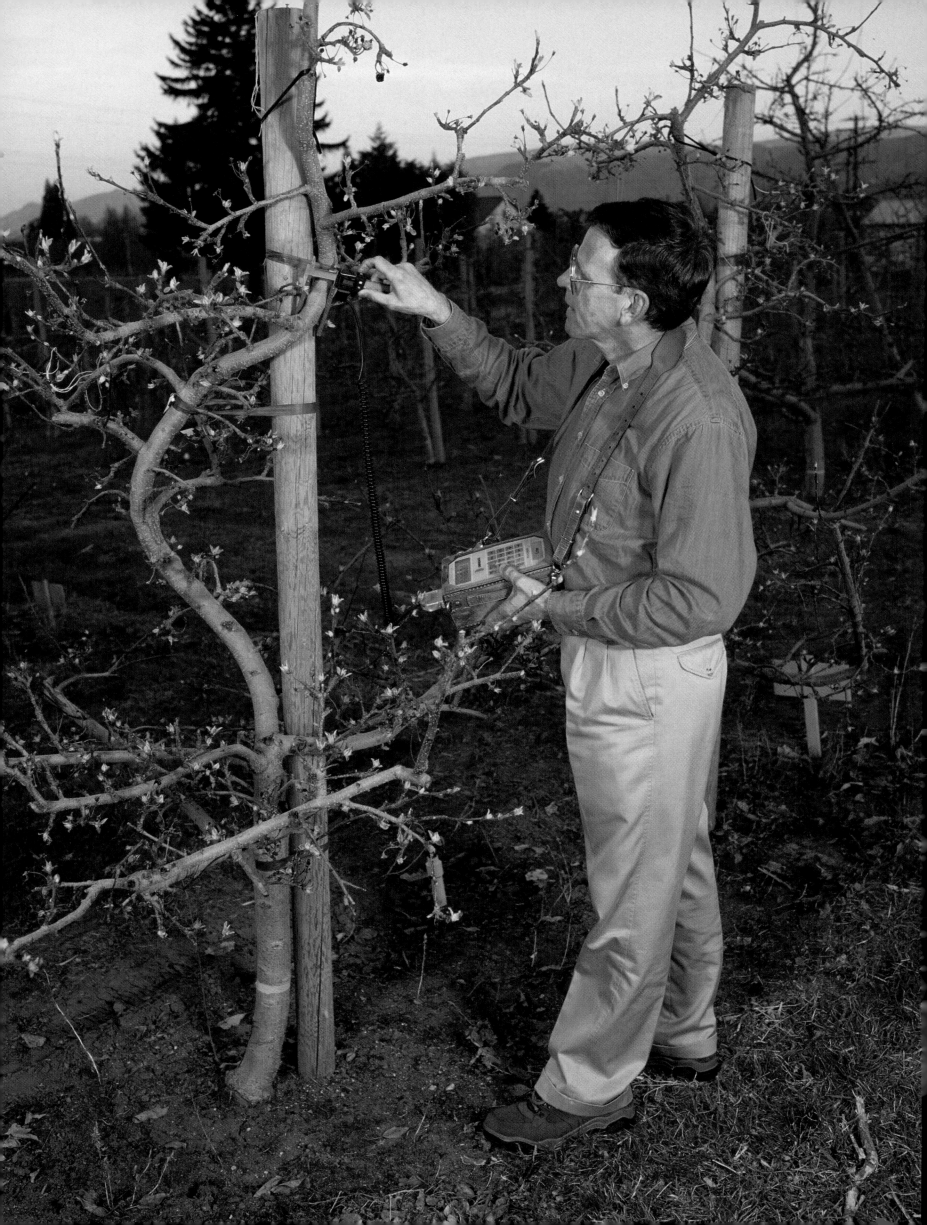

orcharding systems. Part of his success, he claims, is due to the daily reviews that come from visitors who come to his table for a taste of what is new.

The driving force behind the new variety rage has been profit. When Red Delicious prices began to fade in the mid-1980s due to overproduction and then the Alar debacle, growers began to look for other crops to diversify their risk. Older, nonprofitable red strains were pulled out—generally an acre or two each year—and replaced with traditional pear varieties like the d'Anjou or Bartlett. Growers also tried new crops like the Asian pear and several exotic apples—including Granny Smith, Gala, and Braeburn from New Zealand—and the Fuji, a mainstay in Japan for many years. Other varieties planted include Jonagold, Elstar, Criterion, Akane, Empire, and Pink Lady. Some older varieties that are vying for a comeback are Rome Beauty, Winesap, Newtown Pippin, and Spartan.

Orchardists have done well with each of the new varieties when grown and marketed under the right conditions. Their relatively short supply, combined with consumers' new quest for diverse tastes, has made market acceptance and high profits possible. As supplies increase, prices will go down.

Fuji apples, for example, sold for an average $47 a box in 1992, when the crop totaled 750 thousand boxes. The price dropped $10 the following year when the crop doubled in size. In 1994, crop size doubled again, and the average price dropped another $7. Still, even at $28 a box, the price was more than double the $11 to $13 a box averaged by Red Delicious during those years.

◁ *Researchers, such as Dr. Bruce Barritt of the Washington State University Tree Fruit Research and Extension Center in Wenatchee, develop and test new orchard techniques and innovative products to enable Washington orchardists to produce better fruit, which—in turn—allows them to be more competitive with other regions. Here, Barritt uses a caliper to measure a Jonagold apple tree in an experimental high-density orchard system. ▽ A refractometer is used to ascertain the fruit's sugar level. Other tests measure the conversion of fruit starch to sugar, an important means of judging the maturity of fruit and determining the proper time to harvest.*

Plenty of growers are trying to cash in on the Fuji craze. Acreage has jumped from a paltry fifty acres in 1982 to eleven thousand acres in 1993, according to a survey completed that year by the Washington Agricultural Statistics Service. By 1995, many experts believe Fuji acreage had doubled over the two-year span. The total may not seem like much compared to the 110 thousand acres of Red Delicious already in the ground at the time, but Doug Hasslen, state statistician, is quick to point out that more Fuji than Red Delicious have been planted each year since 1990.

"The number of Fujis that have gone in is certainly impressive," said Hasslen. Planting of Gala peaked around 1990, but with six thousand acres in the ground at the time the survey was published in 1993, it has become a major variety in the state and continues to produce sweet, early ripening apples that sell for very good prices, more than twice as much as Red Delicious. In the last year, there has been a resurgence in planting Gala.

There were only about thirty-three hundred acres of Braeburn planted in early 1993, but large acreages have been planted in recent years, including Rancho Royale's 245-acre all-Braeburn orchard in the Columbia Basin. Les Hollowell manages the ranch for California owner Roger Morf.

"Everybody thought we were crazy," Hollowell said of his bold gamble. Although he has yet to prove them wrong, Hollowell expects the ninety-thousand-tree orchard to produce a marketable crop by the fourth year and sixty bins per acre by its fifth year of production.

Gambling is a big part of growing apples. Growing cherries and other soft fruits is even riskier because of their susceptibility to weather. Experimenting with new varieties and new crops is only one way orchardists have to develop a niche that will make them more money or make their operations more efficient to lower their overhead. They are finding new ways to reduce their use of pesticides and other farm chemicals that could become a concern to consumers. They are using drip irrigation and other more efficient watering techniques.

For many years, Bob Harris of Moxee has been considered one of the state's most innovative apple and cherry growers. He is also a poultry farmer. Fryers are the mainstay for the family-operated Harris Farms Inc. Harris is president of the company, which also farms more than four hundred acres of apples and pears, along with seventy acres of cherries. The Harris family once raised four hundred thousand turkeys where the orchard is now. Chickens and cherries may seem like an odd combination, but Harris says the fertilizer from the chickens is great for growing fruit. The poultry operation has also given him a sound economic base from which he has been able to afford to try new ideas in his orchards.

One of the latest ideas is to grow premium Rainier cherries under a rain cover. It took Harris tens of thousands of dollars and years of experimentation to come up with a nylon screen cover that would let wind and sun in, but keep rain out. Harvesttime rains—not unusual in Central Washington—can totally destroy a cherry crop. Harris's ten-acre covered orchard paid back its costs in two years of production and made him a small fortune the next year. "We have to try something different," said Harris. "We can't just sit on our hands and do things the way we've done them for the last twenty years. There's always a better way."

In order to get payback on the high cost of orchard replacement, most apple growers have turned to high-density planting of trees that have been budded to a dwarfing rootstock at the nursery. Instead of growing two hundred trees per acre, as they would have planted apples twenty years ago, they are more likely to plant five hundred or even one thousand trees per acre. The smaller trees are often supported by a trellis or a post where they can grow with less stress and produce better fruit earlier. The process allows the orchard to produce a good crop within three to five years—in some cases earlier—instead of seven or more years for a larger, traditionally grown tree.

Dena Perleberg Ybarra's father, Carl Perleberg, was a pioneer in the process of growing trees close together. Since his death in 1992, Dena, with her sister, Carla, and mother, Gie, have managed the nursery and thousand-acre orchard empire Carl left behind. Carl and Gie started Columbia Basin Nursery in their backyard in Quincy in 1960. The little nursery prospered, and Carl put all his earnings into land in the Columbia Basin. He planted apple trees, lots of them close together, at a time when most growers still grew their trees twenty feet apart and the basin was considered an unfarmable desert.

"Dad prepared us well," said Dena, the company's production manager and principal horticulturist. An attractive woman in her thirties who spends much of her day on the phone talking about root stocks and planting systems with other growers, she enjoys her daily survey of the orchards. Walking through a dense orchard of thick, double-trunked apple trees, she stoops and picks up a handful of dirt and crumbles it in her hands. She makes a mental note to increase the irrigation cycle for the block.

Carl planted this particular orchard on a challenge, she tells me. No one believed he could grow Red Delicious on seedling rootstock four feet apart. He used a scoring technique, cutting the bark around the trunks, to stunt the trees' growth and increase production. The orchard produced a crop within three years and has yielded an average of fifty bins, and as much as eighty-eight bins, per acre ever since. "Dad never did like to plant things very far apart," said Carla, Dena's younger sister. Dena adds, "He taught us to do whatever works best."

Today's progressive growers—and their bankers—try to plan whatever works best at least five years ahead, according to John Thoren, vice president of Key Bank in Wenatchee. Each year, those growers will plant a percentage of their orchards with new trees they have good reason to believe will fill a market niche in the future. They are working to reduce their overhead, reduce the use of pesticides, and keep an adequate labor supply. It is called strategic planning. It is a long-range plan to whatever works best to survive and prosper.

Research

Dr. Larry Gut takes a sip of his double latte, stares into space for a minute, then resumes his typing on the laptop computer in front of him. He does not seem to notice the small children running from their mothers out the door, nor the dozens of people lining up in the busy cafe for their morning espresso. Wenatchee's Starbuck's coffee shop is a noisy, social sort of place, where lots of people buzz in and out in a hurry. Others sit casually over their coffee and chat with friends. But for Gut, it is a quiet place where he can get away from distractions and get some work done.

"I come here every morning for a couple of hours. It's my office away from the office," said Gut, an entomologist who normally works at the Washington State University Tree Fruit Research and Extension Center a mile away. Gut is consumed by his work to such a degree that he is sometimes oblivious to the world around him, a fact that has been good for Washington's fruit growers. They rely on him and other tree fruit scientists to solve their pest and disease control problems and find ways to produce high-quality fruit most efficiently.

Gut is currently working with Dr. Jay Brunner in Wenatchee, Dr. Alan Knight in Yakima, and others scientists on mating disruption techniques to control apple codling moth, a pest that has tormented Washington fruit growers for decades.

Disruption of mating is an innovative way of controlling pests without the use of pesticides; it utilizes synthetic sex scents that confuse pests and disrupt their mating process. The concept has been known for some time now, but before growers can use newly available commercial products with assurance, researchers like Gut have had to perform years of research based on actual orchard trials.

The chemical scents are a type of communicative tool, known as *pheromones*, which are naturally produced by animals. Chemists have reproduced the pheromones and packaged them in small plastic dispensers that can hang on the branches of fruit trees. The male codling moths are attracted by the pheromone, but are

▽ *The Chief Joseph Dam on the Columbia River near Bridgeport offers an ethereal glow to the morning twilight. The Columbia's many dams provide orchardists with irrigation water for their crops as well as electricity for their pumps.*
▷ *Abundant sunshine and water from the Sunnyside Irrigation Canal nourishes a pear orchard near Parker. Without irrigation, Yakima Valley's prime orchard, hop, and grape districts would be as dry as the Rattlesnake Hills in the background. Creating new methods of irrigation—through canals, sprinkling, viaducts, and anything else science has thought up—has been a priority since the arrival of the first pioneers.*

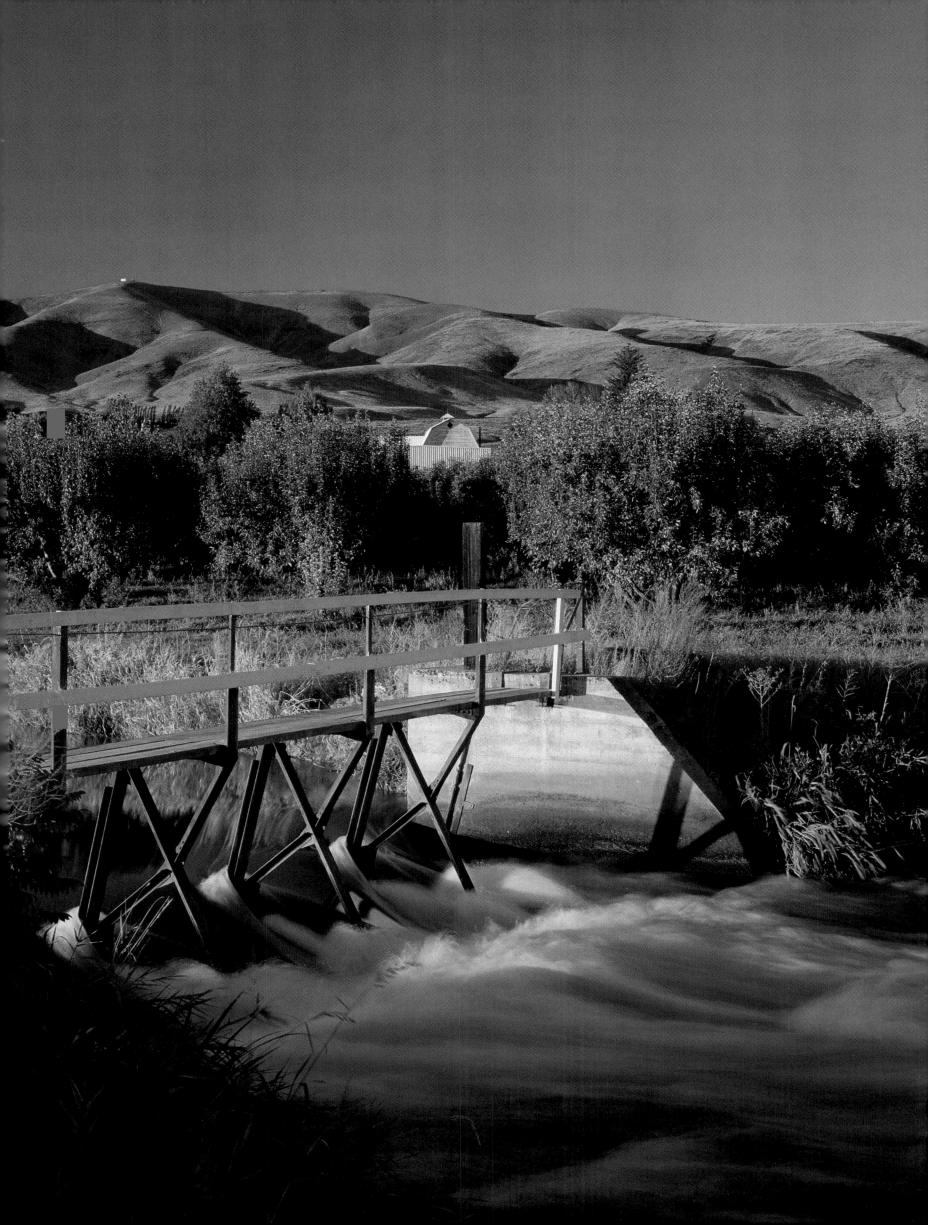

unable to find a real mate. Gut compares the situation to that of a blind man trying to find his wife in a convention hall filled with women who are all wearing the same perfume. Gut's challenge is to determine where growers should place the dispensers and how often they must replace them to get the degree of control needed. His information is used by the chemical manufacturers and other scientists working on related projects, as well as the growers themselves.

The use of the pheromone products has great importance to the industry because it reduces the need for harsh pesticides that also kill the orchard's colonies of beneficial insects. Those beneficials can keep other pests in check and further reduce the need for other insecticides. Mating disruption is just one of the many tools that have been developed as part of a relatively new philosophy called integrated pest management, or IPM. The concept is based on a strong working knowledge of orchard ecology and use of natural enemies to control pests with a minimum of any pesticides that could possibly cause a negative impact to the environment.

Washington apple growers have used IPM practices since the 1970s, largely thanks to the efforts of one man, Dr. Stanley Hoyt. Hoyt recently retired as superintendent of the WSU Tree Fruit Research lab in Wenatchee. He had served the fruit industry as a researcher for twenty-five years before taking on the center's top post for another decade.

I talked to him one day at his office as he was packing his books and papers to make room for his replacement. As the lanky scientist filled a box with a wall full of awards presented

◁ *For decades, this ancient irrigation flume, recently reconstructed in concrete, provided water to farmers near Oroville in the Okanogan Valley. Open flumes are being replaced by closed systems in some areas to avoid water loss to evaporation.* ▽ *Irrigation management is a precise science: too little water, and these Okanogan County Red Delicious apples will not grow to marketable size and quality; too much water, and collar rot—a fungal disease that can kill the tree—may set in. Consultants design systems to fit each orchard's unique characteristics, taking into account geology, lay of the land, climate, water availability, planting system, and fruit varieties.*

him by the fruit industry interspersed with colorful drawings painted by his grandchildren, he told me he had been hired in the late 1950s to help find alternatives to DDT when that wonder chemical was becoming less effective against codling moth. But before long, he switched his research emphasis to mites.

"Mites were an awful problem and getting worse. We were using substantial amounts of miticide, and resistance patterns were growing. There were a lot of brown orchards from mite damage." Hoyt set up a test orchard to see what would happen if the trees were *not* sprayed with DDT and the heavy miticides being used at the time. He found that the pesticides were responsible for eliminating the mites' natural predators. He also found that those natural predators could be brought back by eliminating certain sprays.

However, convincing growers that they could reduce pest problems by *not* using the chemicals they had relied on for two decades was no easy trick. The entire project might not have gotten very far without major government funding from the Johnson Administration after the publication of Rachel Carson's *Silent Spring*, admits Hoyt, who, although he may at times be referred to as the "father of integrated pest management," does not always agree with the heavy-handed tactics of the environmental movement. That pressure and the way the government has responded to it has sometimes done more harm than good, in his estimation, by eliminating those chemicals that have proven useful and creating barriers for the registration of newer and safer farm chemistry.

Hoyt calls his ground-breaking discovery a unique situation in which he found himself in the right place at the right time to solve a problem, one that would stay solved for a long time. He achieved this result by reducing the use of chemicals, fostering environmentally friendly practices, and cutting costs to growers. The entire orchard ecosystem is much more complex today, he said. There were fewer pests to cause problems after a long period when wide-spectrum sprays were used.

"Everything about fruit growing has changed, mostly for the better, but it certainly has not made it less complex," he commented. Today, there are new varieties of fruit that researchers and growers know little about, more insect problems, more pressure to produce quality fruit with fewer chemicals, and less public support for research. Hoyt said there are many unsung heroes in fruit industry research. They are just people doing their jobs.

"If you solve a problem, you get a lot of credit. If you keep a problem from occurring, you've done your job well, but you don't always get the credit. That's what most of insect control is all about," Hoyt said.

Insect control is only one small part of what tree fruit research is all about. Dr. Gene Kupferman, for instance, is normally involved in at least a dozen research projects that center around controlled-atmosphere storage and the postharvest handling of various tree fruits.

The WSU researcher lets warehouse managers know how they can store fruit longer and get improved quality and how to pack fruit with fewer scrapes and bruises that can bring down its market price. Kupferman hosts the annual Washington Tree Fruit Postharvest Conference, bringing together controlled-atmosphere storage experts from around the world. Held on alternating years

in Wenatchee and Yakima, the conference is the biggest event of its kind in the world.

Dr. Rodney Roberts, research leader at the U.S. Agricultural Research Laboratory in Wenatchee, oversees several projects involving scientists at the station. His own research focuses on finding biological control agents to fight off pathogens that cause fruit to decay while in storage. Synthetic chemicals are still widely used for that purpose now, but since they are the last additives applied to the fruit before it reaches consumers, the products are coming under greater scrutiny by agencies like the U.S. Environmental Protection Agency. Postharvest research receives a significant share of grants from various grower-funded agencies like the Washington Tree Fruit Research Commission. The reason is simple, said Roberts.

"If you go to all the trouble of getting a crop through spring frosts and put all that money into production and harvest, you don't want to lose it in storage," he said.

According to George Ing, a grower from White Salmon near the Oregon border, and manager of the Washington Tree Fruit Research Commission, growers now feel more pressure than before to pay a larger share of research costs. Public funding for such projects is largely a thing of the past, said Ing, an imposing, barrel-chested man who has led the commission through much of its fifteen-year existence. Furthermore, research costs are likely to grow much higher in the future because most of the simple problems have been solved.

"All of the lower limbs have been picked," said Ing, citing an expression frequently used by researchers and fruit pickers alike. Monumental achievements include the common employment of chemical thinning, the use of dwarf root-stocks, and the development of controlled-atmosphere storage that allows apples to be marketed year-round. Washington fruit growers pay assessments totaling approximately three million dollars annually to fund research projects.

Kinder, Gentler Growing

Because of building consumer concerns over the use of synthetic pesticides, orchardists have elected to try growing their fruit using fewer and less toxic chemicals. Any toxic products that are employed are used in very dilute applications. In recent years, the chemicals themselves have, in many cases, been reformulated or replaced by others that are more selective and less toxic to mammals. Reducing both the environmental impact and the chemical residues on the fruit has been a major preoccupation of the fruit industry. Apples have never been safer or healthier to eat than they are today.

Still, some growers have attempted to grow fruit without the use of any man-made chemicals whatsoever. Organic growers go one step further than those using integrated pest management practices, which include the use of synthetic chemicals when necessary. In order for Washington fruit to be certified organic, growers must raise their crops using only fertilizers, mulches, and pest controls derived from animal, mineral, or vegetable matter and without the use of any synthetic products. That is a tough order, as many growers who tried organic farming in late 1980s found out.

Following the Alar scare in 1987, for a short time consumers were willing to pay a high premium for fruit they were assured had not been treated in any way with toxic pesticides. Some growers, hoping to cash in on the organic fruit premium boom that followed CBS's 60 Minutes broadcast condemning Alar, quickly found that organic farming entailed a great deal more work and expense than nonorganic farming methods. It was also a huge challenge to produce fruit of comparable size and quality. In fact, as the consumers gradually overcame their pesticide paranoia and returned to shopping with their eyes for the most attractive fruit obtainable at the lowest price, the demand for organic fruit began to drop, as did the price premium and the number of growers who were willing to experiment with new organic methods.

Those who found success were mainly growers who were wed, not to the opportunity for profits, but to the philosophy of producing food in the most natural way possible. One is Ray Fuller. He has grown organic apples and pears at his eighty-five-acre Stormy Mountain Ranch overlooking Lake Chelan since 1982. He claims that common sense and a concern for the safety of both his workers and himself have been the motivating forces behind the painstaking methods of producing quality fruit organically. His success in the market place indicates that some consumers also feel safer with this method.

"I couldn't understand why we would want to spray a pesticide to kill one pest and by doing that kill off a lot of other insects that would help us," said Fuller, a compact, energetic man in his forties who describes his pest control program as manipulation of nature

▽ *Perfectly colored Fuji apples, like these at Nickell Orchards in Pateros, bring top dollar in Taiwan. Washington growers are quickly learning how best to manage the tricky new cultivar that originates from Japan. Some industry leaders predict the sweet, late-harvest variety will one day replace the Red Delicious as the number one apple grown in the state of Washington.* ▷ *With its great, complex taste and good storage capability, the Braeburn apple, developed in New Zealand, has fulfilled the search by some growers for the perfect apple. Fuji and Braeburn apples are picked in late October or November, after the Golden and Red Delicious harvest.*

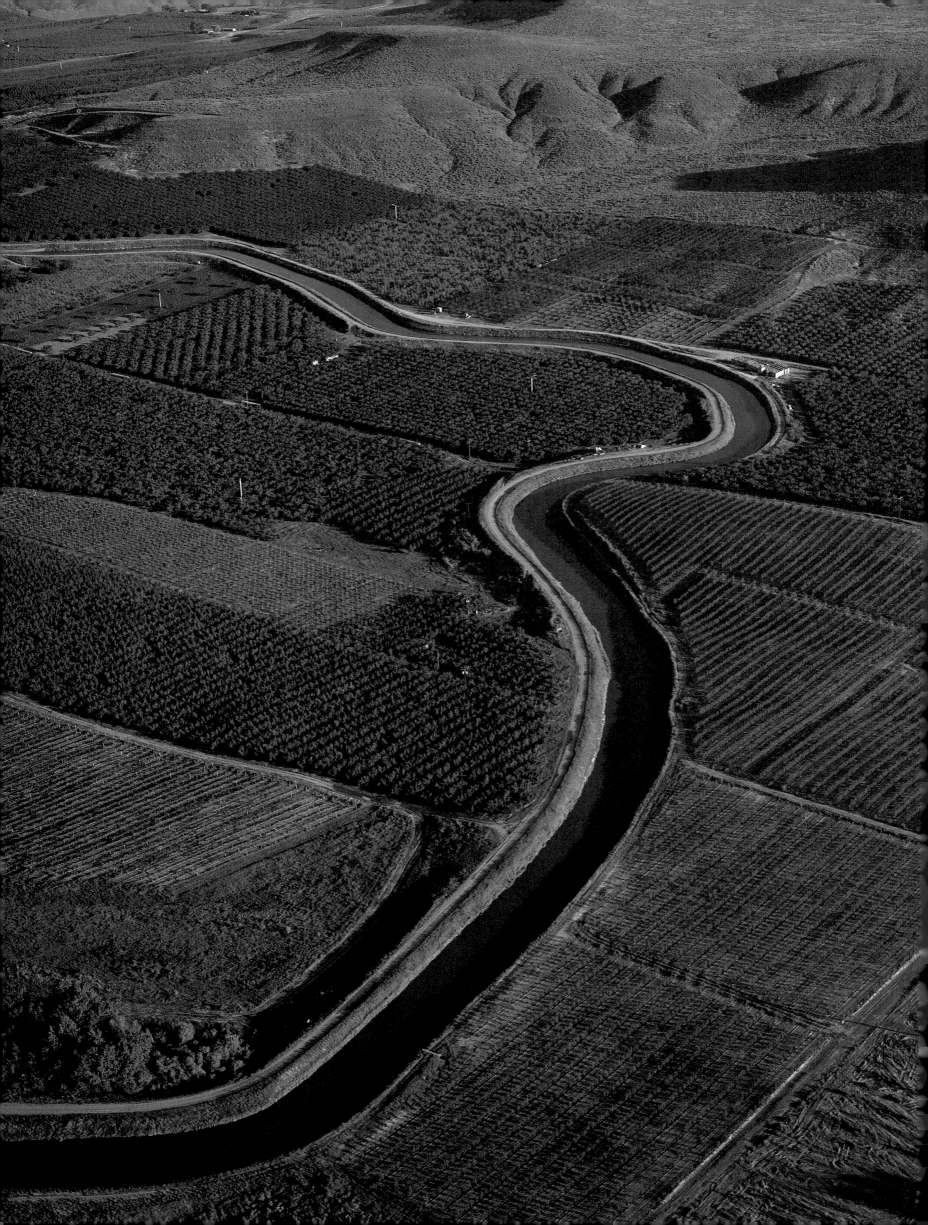

in soft ways. "It makes more common sense to me to operate this way, even if it is more work." More work, yet easier, he notes with irony. "There's fewer surprises. Nature seems more predictable when we influence it less."

Phil Unterschuetz opened an all-organic farm product supply house in Wenatchee in 1983. Since that time, he has been committed to serving the needs of organic orchardists and home gardeners. He has never made efforts to try to convince other growers to go organic. "I never have, never will. There's a lot of risks," said the former college forestry instructor. He is convinced that natural products like fish oil, blood meal, manure, and natural pesticides pose fewer dangers to mankind and to the earth's longevity. Sure, organic products can be toxic, he argued, but they break down naturally and do not build up in the soil, the water, or in the fat tissues of animals as some synthetic products may. They do not cause huge swings in soil nutrient content, but contribute lightly to the organic content of the soil, which adds to natural soil vitality.

There are those today who will argue the need or practicality of producing fruit with only organic products, but the future of the industry is clearly moving in the direction of more sustainable farming methods akin to organic growing. Consumer attitude and new government regulations have already begun to reshape the way growers think, said David Granatstein, coordinator for Washington State University's Center for Sustaining Agriculture and Natural Resources.

"Consumers still appreciate farmers in the romantic sense," Granatstein commented. "They see farming as a good, ideal life. The flip side is the belief that farmers are poisoning the earth." That is hardly a fair assessment, particularly by those who are unwilling to pay more for food that is organically or close-to-organically grown.

Many growers are getting tired of the criticism and the onslaught of new regulations. Whereas European fruit growers receive additional support from their governments to farm without chemicals, the government here is, in many ways, making organic farming more difficult.

Some growers have become discouraged, but others are taking the lead into a new era of farming ideology. A few large Washington packing houses are now providing their growers with an environmental checklist to help them produce the best possible fruit with less chemical applications and with minor environmental impact. Stemilt Growers, one of the state's largest apple and cherry packer-marketers, started its Responsible Choice program around 1990. The "ecologically conscious" approach is also applied to all of its other operations, including storage, packing, shipping, waste disposal, and even the fuel efficiency of its vehicles. Fieldmen advise the company's nearly three hundred participating growers regarding how to cut down

◁ *An aerial view of the Roza Canal and the Rattlesnake Hills near Yakima reveals a patchwork of agricultural diversity that supplies the nation and the world with produce as it funnels in billions of dollars to the state's economy. The Yakima Valley is a cornucopia of agrarian wealth, boasting apples, cherries, plums, apricots, nectarines, peaches, and pears, along with grapes, hops, asparagus, wheat, and numerous other crops.*

on their use of chemicals and to how to use safer chemicals when it is necessary to use them at all.

"We've seen an overall need for the industry to respect the environment and try to do a better job," said Tom Mathison, Stemilt's president. Mathison said the company makes an effort to listen to what consumers are saying and analyze carefully what it hears. The words "less chemicals" have come across loud and clear, he said.

Although the program is voluntary, most growers are giving it a chance because they know the old broad-spectrum sprays are not going to be around in the future, said Derek Carlson, an integrated pest management specialist who recently left the company to work on his own family orchard. "The growers realize that environmental pressures are pushing in their direction," he said. The program takes more time, requires more education and is not guaranteed either to save growers money or to earn them more profits, he said, although it is likely to do both. The real objective is to give the consumers what they want and make Washington apples the safest, most nutritious product possible.

Global Marketing

The satisfaction of growing perfect apples is short-lived if they cannot be marketed at a profit. For that reason, Washington growers set out early to establish one of the best-organized and most-respected promotion and marketing programs in the world. It is a necessity with annual production nearing one hundred million boxes annually.

Apples can be marketed by the individual growers, by the warehouse, by a specialized marketing agency, or by a private fruit broker who may work out of his home. Not counting the one-person operations whose numbers vary from year to year, there are more than three hundred larger marketers in the state. Nearly all of them are smaller than Oneonta Trading Corporation. One of the state's top one hundred income-generating companies, the Oneonta Trading Corporation handles approximately ten million packs of produce annually, including more than five million boxes of apples.

Seven clocks hang on the wall at the Oneonta office in Wenatchee, overlooking the Columbia River. At a glance, salesmen can see the time in Hong Kong, Taipei, Tokyo, London, Stockholm, New York, and Wenatchee. Eight salesmen wearing jeans, sweatshirts, and headphone sets fill the spacious room with lively chatter about apple grades and size, price, and transportation. At times, usually when the sky outside is still black but it is prime business hours on another continent, the room grows frantic with activity. Three assistants scurry around the room gathering up a mountain of paperwork. Salesmen like Tracy King become animated, gesticulating at a reflection in the window while talking to a faraway voice.

"Sometimes it gets kind of wild in here," said King, an athletic-looking young man who keeps a portrait of former President Ronald Reagan on his desk next to a photo of his family. "You should be here around Christmas."

The key to successful sales is building good relationships and knowing what is going on, King said. Good relationships with

each warehouse, with the growers, and with every buyer are absolutely essential. Salesmen need to know what is going on with local and world crops, as well as global economics. Their success is based on being able to match up each client's needs with the most appropriate product.

Selling fruit in years when many of the apple-producing countries have large crops can be a challenge. And with a recent trend toward larger crops and more competitors, marketing seems to become tougher each year. But generally, quality apples do a good job of selling themselves.

Washington apples have established a well-earned reputation for excellence, and most markets are aware of their sales power. Apples—particularly Washington state apples—are one of the most profitable items a grocery store can handle, according to Steve Lutz, president of the Washington Apple Commission.

The Washington Apple Commission is in charge of promoting each year's crop and trying to increase apple consumption. Apples rank second only to fresh bulk potatoes as a profit-maker in the produce section, accounting for more than 7 percent of the total produce department sales and nearly 9 percent of the weekly produce department profits, Lutz cited from a recent supermarket survey. Furthermore, it is perishable foods that make up for the losses that are sometimes experienced in most of the other store departments.

Because of their high profit margin, it is not difficult to convince stores to give Washington apples prime display space, he said. Trying to get stores to boost their gross income by selling more apples at a lower price is another matter, however.

"Their feeling is that if they're going to cut profit on Washington apples, they make it up on volume, but they also have to balance other items in the meantime. They don't want to lower prices for more than a week at a time," said Lutz.

The Washington Apple Commission sponsors contests each year in which produce buyers and brokers can earn points and win a trip to Washington Apple Country. The contests have several benefits—encouraging stores to sell Washington apples with newspaper and radio ads, and offering salesmen who take the tour a chance to gain fuller understanding of what goes into growing and handling the product.

When attempts to boost per capita domestic consumption fail, the weight falls on export sales. The average per capita consumption in the United States is about thirty pounds. That is well above the world average consumption of sixteen to nineteen pounds annually, but well under the forty-five pounds for Europeans. In Italy and Holland, average consumption is an astounding seventy-seven pounds per person each year. The Commission's promotional emphasis leans heavily toward the developing nations, said Terry Elwell, the Commission's foreign sales director. "You want to fish where the fish are," said Elwell, a tall Texan in cowboy boots, jeans, and sport jacket, who attracts even more attention in Third World countries than he does in his hometown of Wenatchee. Interest is in those countries that produce fewer apples than needed and countries that have large populations with lots of money. The most important target area today is Asia, Elwell said during a recent trip to Japan to celebrate the importation of the first Washington apples. Expectations are that Japan will be a major market, along with China, Indonesia,

Thailand, and Vietnam—all countries where U.S. apples have been recently introduced and where the economies are developing at a fast rate.

Japanese consumers are used to paying high prices for food. But they view Washington apples as an economical treat, rather than the luxury item it is considered in many other countries. Consumers can no longer afford the products Japanese growers raise on their tiny plots of land, said Brent Evans, the Apple Commission's Asian trade representative. They are now looking for value, and a new era of chain stores has arrived for just that purpose.

"Japan can't provide even half of what it needs," said Evans, a former sales manager for a worldwide supermarket chain. Looking sophisticated, and a bit like Michael Douglas in a long, black wool coat and silk scarf, Evans is very much at home in Tokyo and other parts of Asia.

Evans had been schooled in Japan and speaks the language fluently. He commented that agriculture in Japan is expected to erode another 30 percent by the turn of the century, making foreign imports even more of a necessity than they are today. Only about 750 thousand boxes of Washington Red and Golden Delicious were allowed to be imported in 1995, the first year after lifting a ban imposed on U.S. apples for nearly twenty-five years. Evans expects the market will soar to several million boxes annually in the near future.

Getting the doors open to Japan—as with any new market—takes patience, persistence, and no small amount of political savvy. Even President Bill Clinton got into the act, first threatening trade retaliation if apples were not allowed into Japan as a symbolic gesture of improved trade relations, and then in early 1995, after the opening, when he presented Japanese Prime Minister Tomiichi Murayama with a gift basket of Washington Red Delicious.

Washington growers had to convince Japanese growers and agricultural inspection officials that no foreign pests or diseases would be imported with the apples. They also had to convince them that these imports would actually help their own domestic apple sales. Growers Ed Pariseau and Tom Mathison have participated in several capacities over the years to get apples into the country.

"The Japanese have been very consistent in their opposition to this, but a deal is a deal," said Pariseau, the cowboy-hatted president of Brewster Heights Packing and a longtime member of the Northwest Horticultural Council. "They know we're not blowing air when we say it will expand their market."

Washington apple growers are experts at making such deals—and making them pay off. They now ship to more than fifty countries around the world. About 30 percent of the entire crop is exported.

▷ *Early traders who traveled the Caribou Trail passed by McLaughlin Falls on the Okanogan River north of Riverside.*
▷ ▷ *Endless rows of Fuji apples near Pateros reflect the changing climate of the state's apple industry. Although Red Delicious—still considered the leading variety—makes up two-thirds of Washington's apple crop, new varieties like Fuji, Gala, Braeburn, and Jonagold are gaining in popularity.*

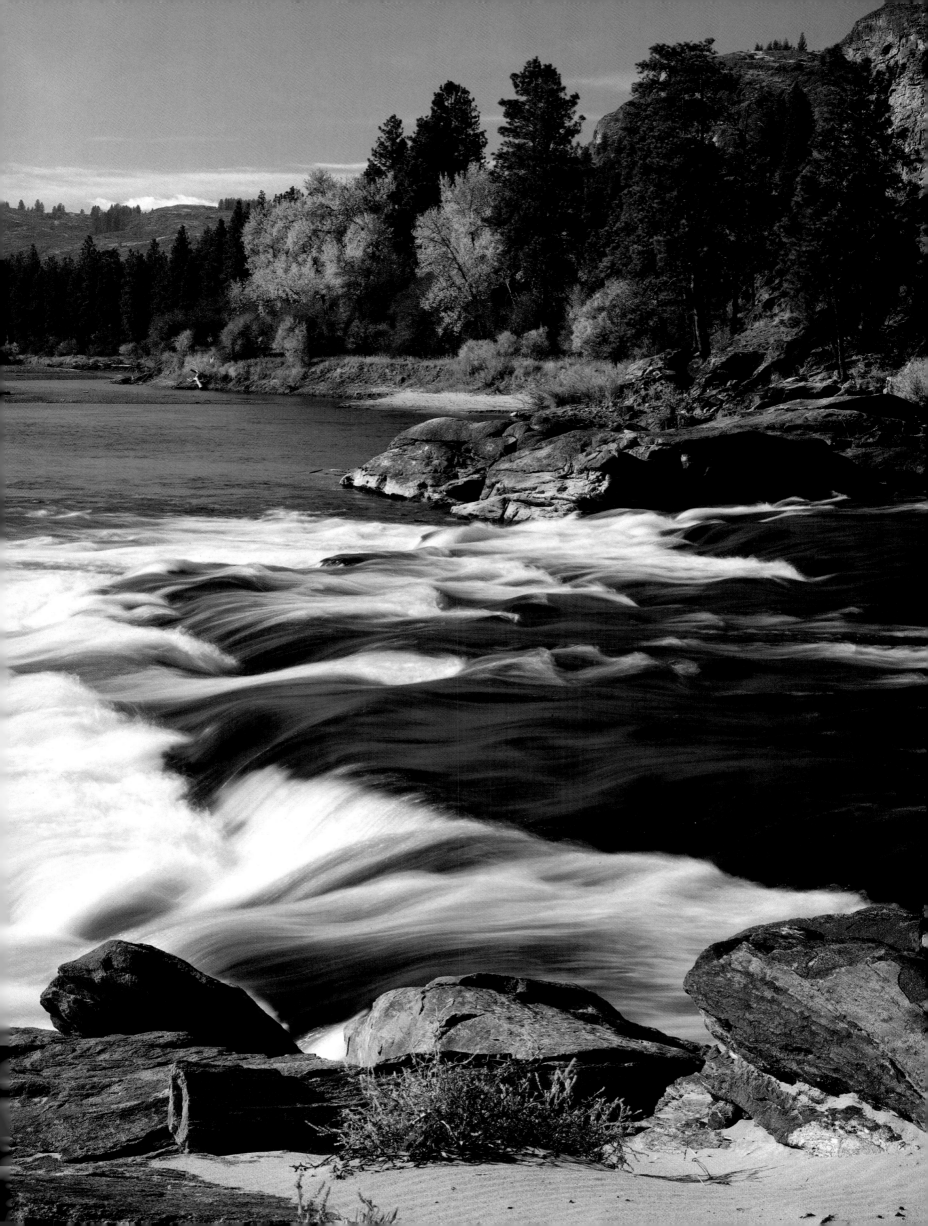

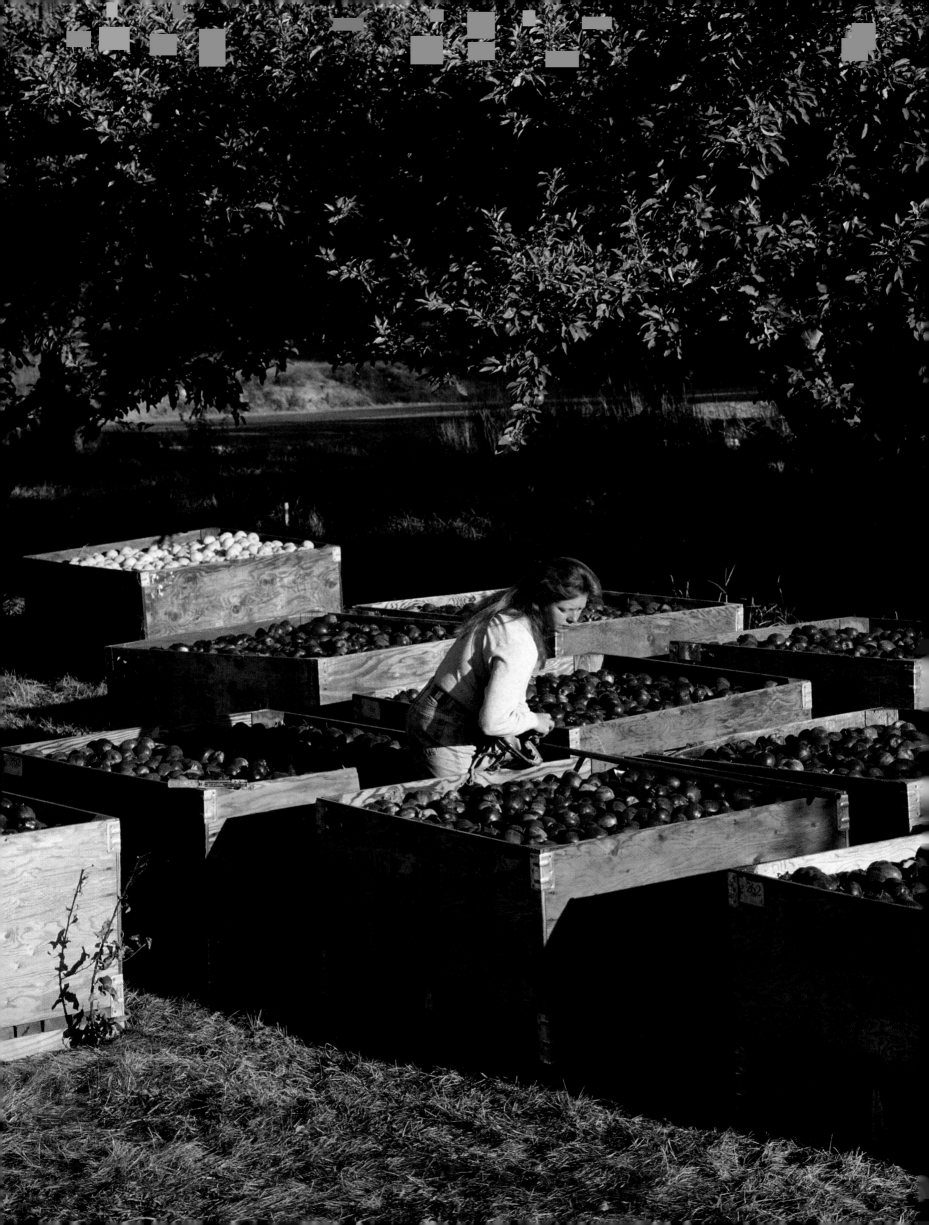

◁ The whole family pitches in to make sure the best possible crop comes out of this small orchard near Tonasket, close to the Canadian border. Hired workers are taught to handle apples like eggs. Bruises and cuts must be avoided at every stage of harvest. This orchard co-owner makes sure bins are leveled so apples don't get crushed when stacked two-up on a truck that will transport them from orchard to warehouse. △ Bright fall willows counterpoint Ponderosa pines and a rugged granite outcrop near Pateros in the Okanogan National Forest, not far from where growers have converted nature to productive farmland.

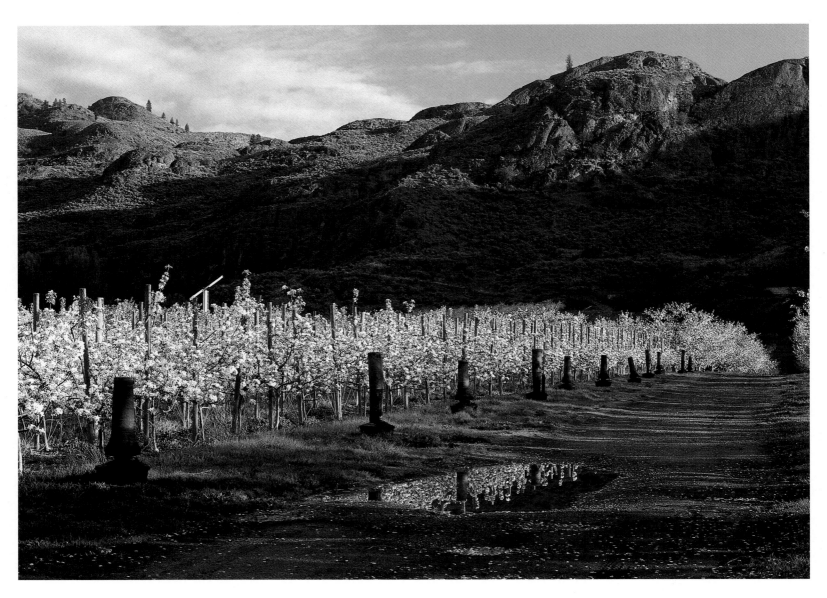

△ A young, high-density block Fuji and Granny Smith apple trees in full bloom contrasts the barren hills just west of Oroville. Clean-burning oil heaters—once called smudge pots for the dark clouds older units cast in the spring—are ready to protect the fragile blooms from frosty nights.
▷ A wagon wheel stands as a reminder of the state's long apple growing history. Washington's first apples were planted in the mid-1800s to provide fruit for military outposts and early settlements. Before the turn of the century, Washington apples were being shipped to the East Coast by train and to other world markets by steamer and clipper ships.

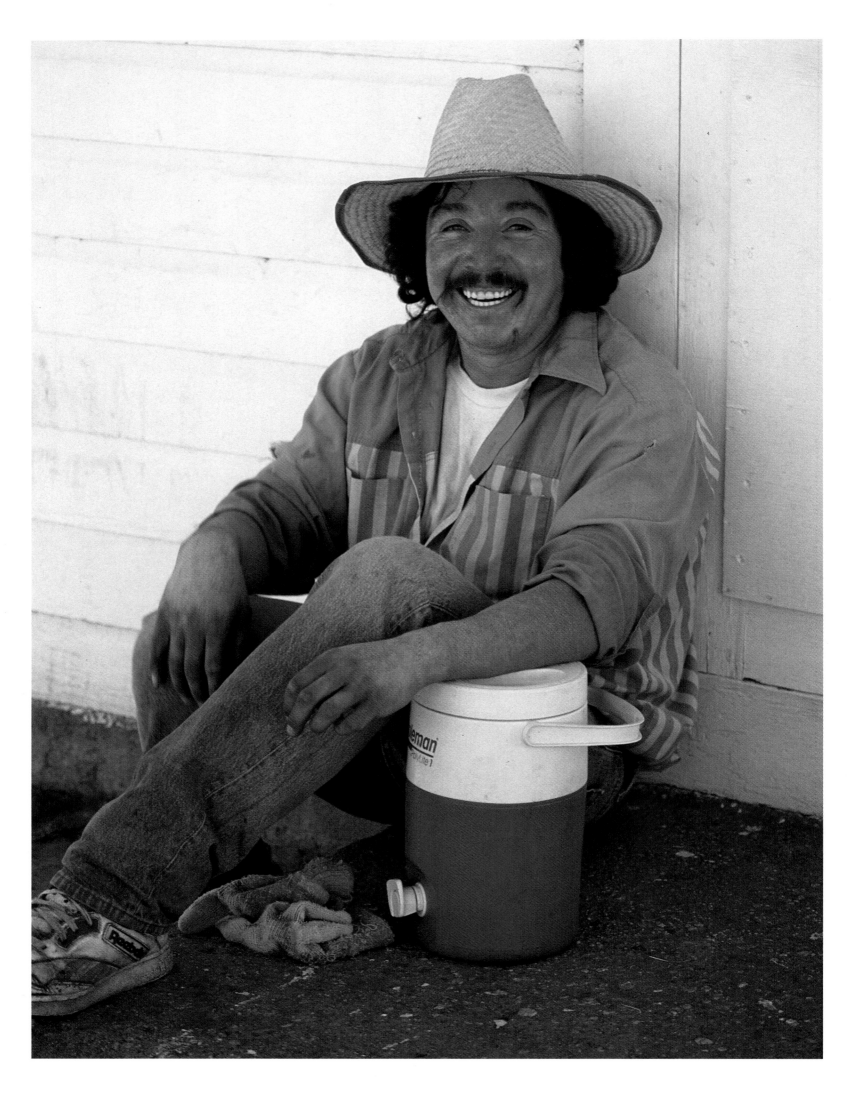

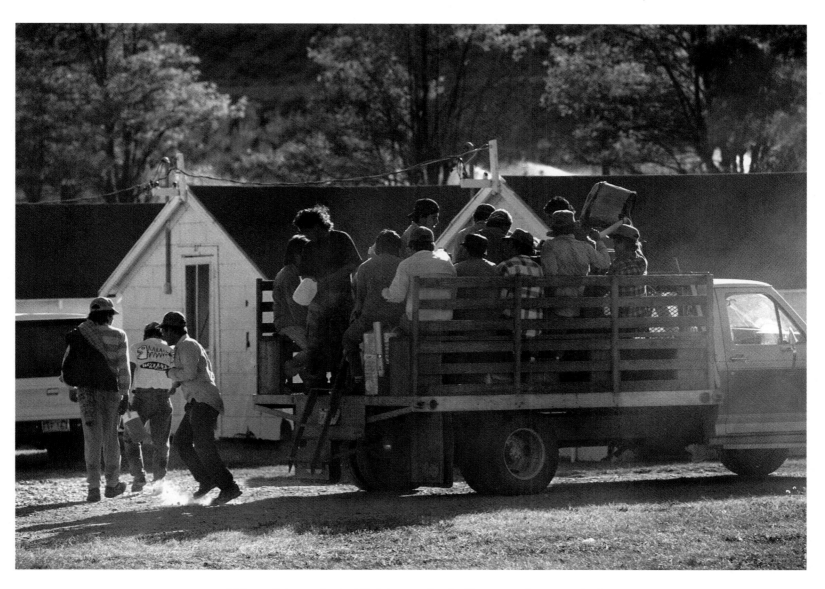

◁ Most of the apples in Washington Apple Country today are picked by Hispanics like Jaime Lugo. Workers migrate north for the apple harvest to earn good wages, providing them with a bankroll that can buy them a farm in their native Mexico. Others bring their families, settle down in the area to year-round orchard work, and seek U.S. citizenship. △ Lugo and fellow workers arrive back in camp at dusk after a full day's work picking in the orchards surrounding their humble but adequate housing. The work is hard, but the pay is good and the overhead low.

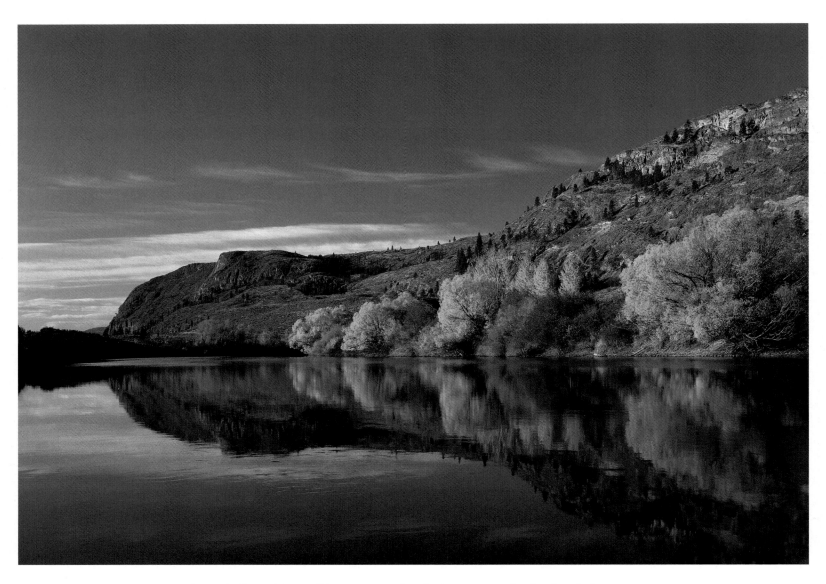

△ Something wild yet serene lured pioneers up the banks of the Okanogan River to fertile soils, hot summer days, and cool nights—a land that turned out to be perfect for growing apples. Okanogan County led the state in apple production for many years. New high-density plantings in the Columbia Basin have changed that in recent times. ▷ Sumac adds a touch of fall brilliance to desolate Okanogan County hillsides. Erosion caused by wind, rain, and melting snow has plowed the foothills into badlands along the Similkameen River near Oroville.

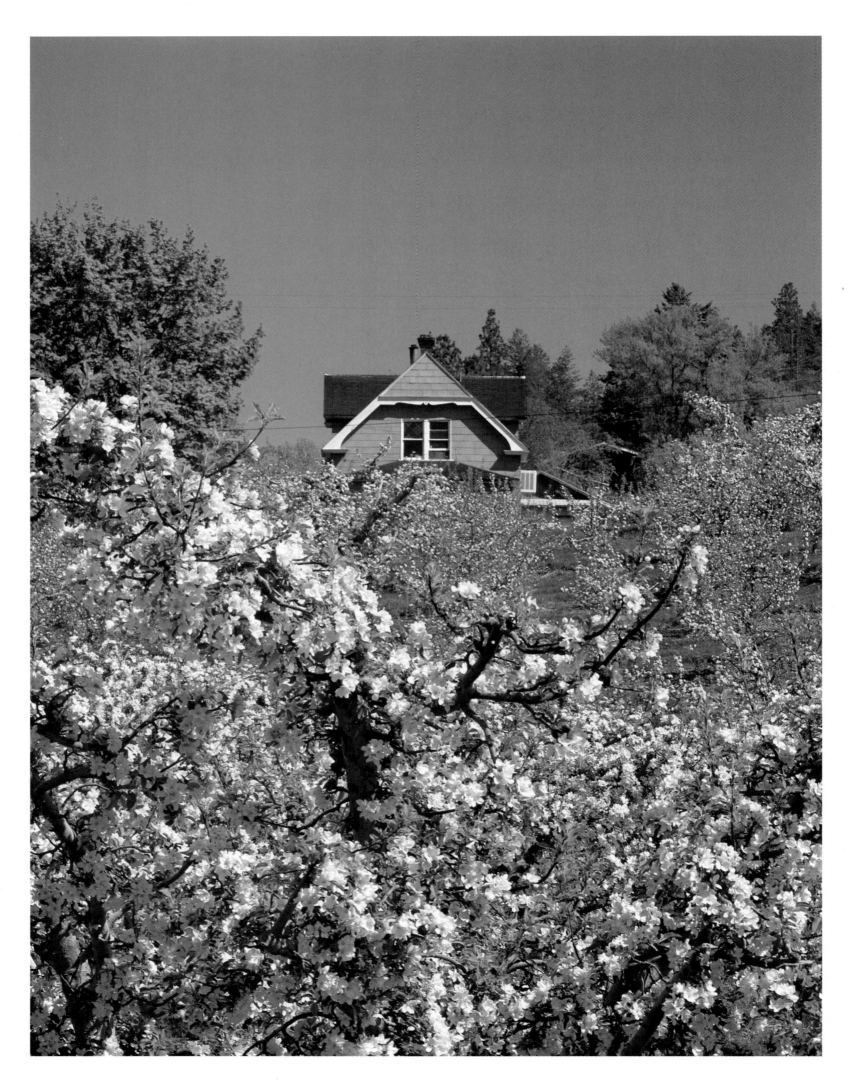

◁ An early 1900s farmhouse appears to float in a sea of fragrant apple blossoms near Loomis, west of Oroville. △ In the early 1850s, Okanogan Smith planted some of the first apple trees in Eastern Washington, including this Winesap tree that continues to produce a full crop along the shore of Lake Osoyoos, near present-day Oroville.

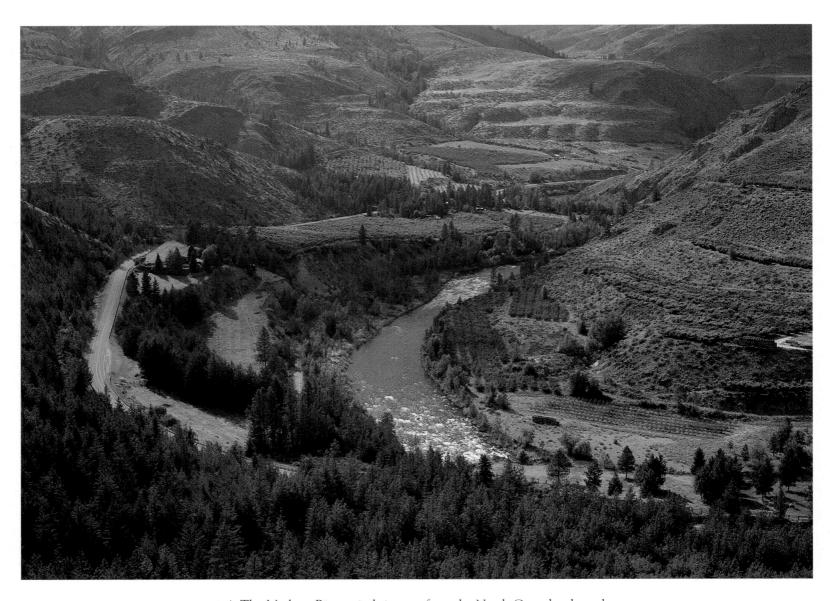

△ The Methow River winds its way from the North Cascades through the smaller Buckhorn Mountains, where apple and pear orchards are planted on narrow benches. A few miles southeast, the Methow flows into the Columbia River at Pateros. ▷ An Okanogan County fence is completely cloaked in wild roses, its "fall coat" decorated with rose hips beneath a collar of clematis, whose seed has already burst from the pods.

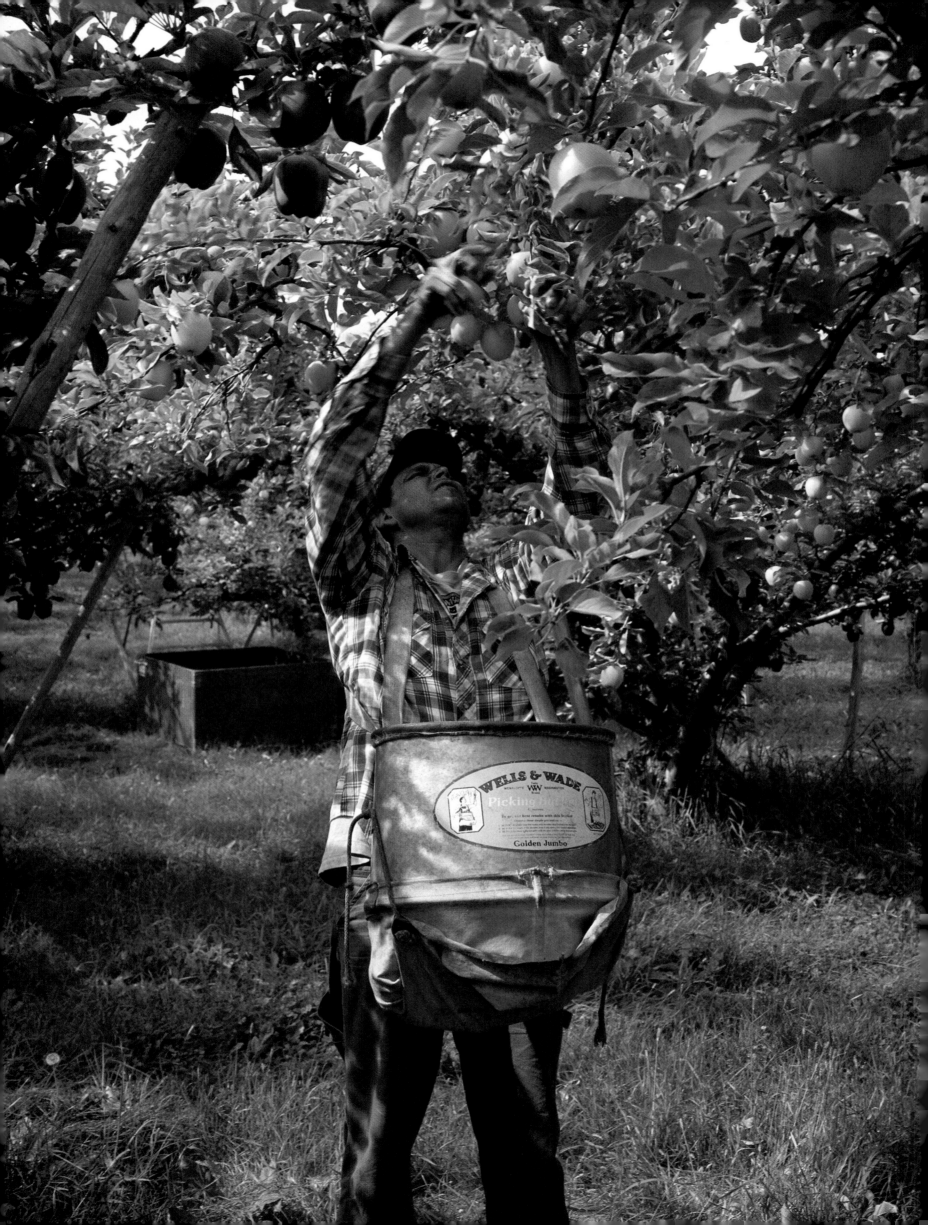

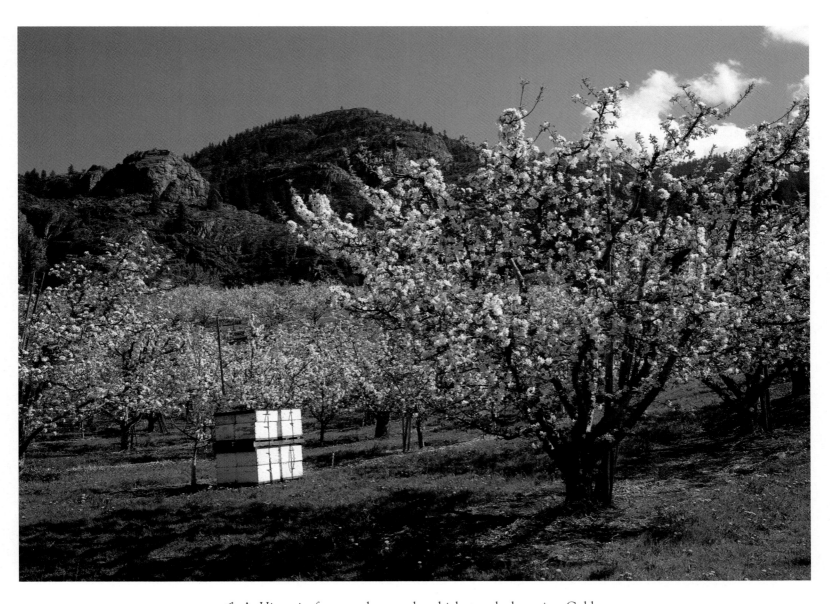

◁ A Hispanic farm worker reaches high to pluck a ripe Golden Delicious. He grasps the apple deep in his palm and lays it in his foam-lined bucket to avoid bruises that can make the fruit unmarketable. △ Beehives are stacked in this Okanogan County orchard throughout the bloom period. Rented out by beekeepers, the hives are moved in the cool of the night from orchard to orchard. These hives may have last helped pollenize almond trees in California. Their next stop could be an alfalfa field in western Montana. ▷ ▷ A walnut tree casts a shadow across a county road near Entiat, a valley known for its d'Anjou pears.

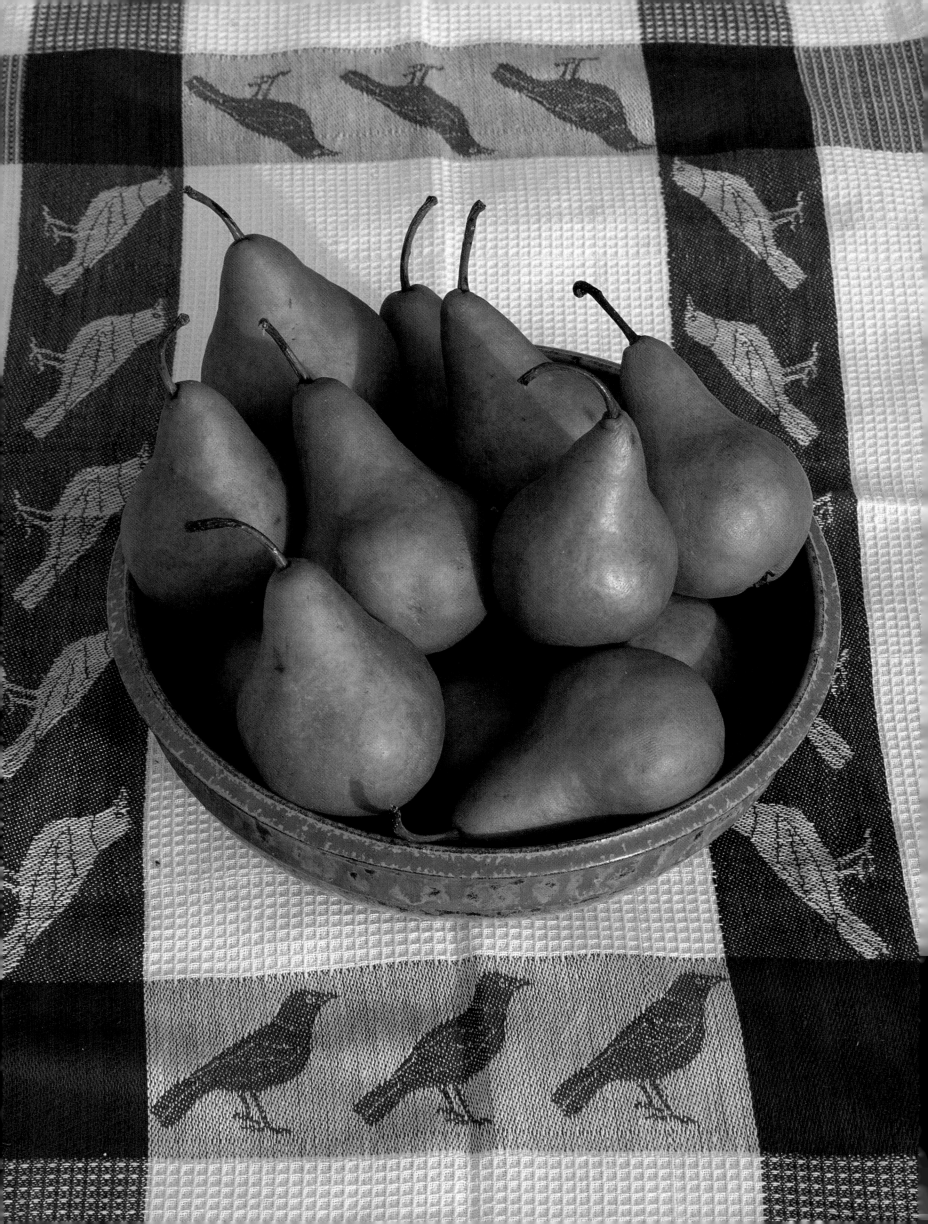

◁ A bowl of Golden Russet Bosc pears is as aesthetic as it is taste-tempting in a table display. The slender Bosc is quickly becoming a favorite among growers and consumers alike. △ A row of Lombardy poplar trees protects a block of young high-density apple trees from high winds that blow so frequently along the Columbia River near Orondo.

△ With snow-capped wheat fields of Badger Mountain as a backdrop, a young army of orange-hued branches reaches for the sky from an orchard of open-centered apple trees near Wenatchee. New growth will be pruned back later in the winter so tree nutrients concentrate on fruit rather than on unneeded wood. ▷ Overlooking the Columbia River, barren Chelan Butte rises majestically from Lake Chelan. Orchards and wheat fields rim the mountain. In better weather, hang-glider enthusiasts from around the world claim the top as a favorite take-off point.

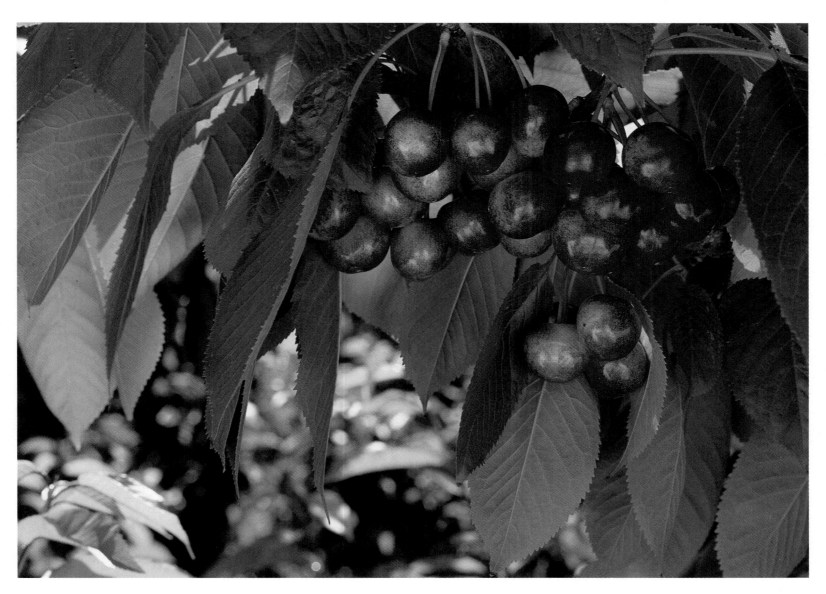

◁ Takahide Masude relaxes after inspecting a pallet of Rainier cherries bound for Japan. A buyer for a Japanese brokerage company, Masude sees part of the millions of dollars' worth of cherries shipped annually to Japan by Washington growers. The pallet he leans against represents a $10,000 sale. △ An exceptionally brilliant-colored branch of Rainier cherries becomes even more appetizing in crisp morning light. The large, ultra-sweet cherry must be handled with care. In some orchards, the Rainier is grown under cover for protection from wind and rain.

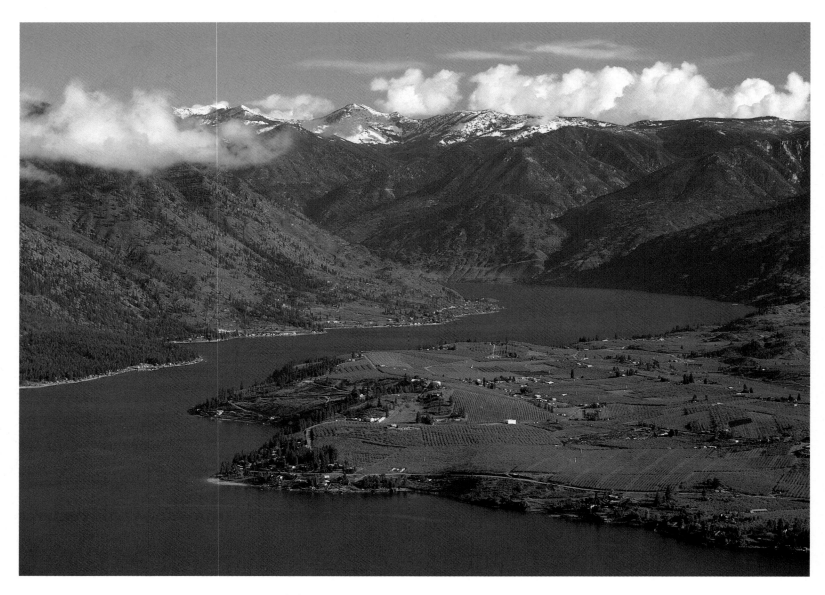

△ Surrounded on three sides by Lake Chelan, Manson's apple orchards offer a unique micro climate said to give the fruit exceptionally deep color. ▷ Granny Smith is the third most heavily produced apple in Washington. It is perfect both for cooking and for eating out of hand.

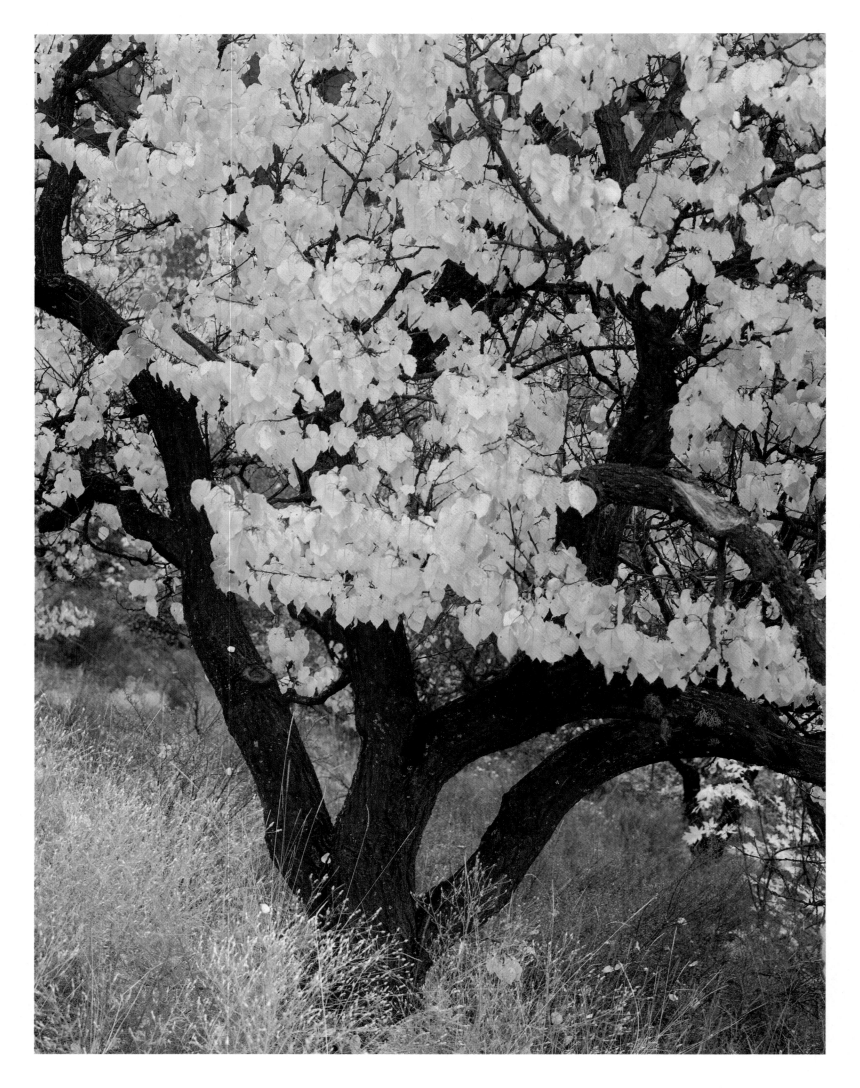

◁ A fall cold snap paints colors from Gauguin's palette on an apricot tree in an abandoned orchard in Derby Canyon, north of Peshastin. △ Saddle horses run the open range near Wenatchee. Domestic animals share North Central Washington's open range land with deer and elk.

△ The blossomed boughs of a Blewett Pass pear orchard add fragrance to a farm worker's drying laundry. ▷ Above the Wenatchee River Valley, sunflowerlike arrow-leafed balsamroot, purple lupine, and biscuit root embroider the hillsides with their variagated colors each spring.

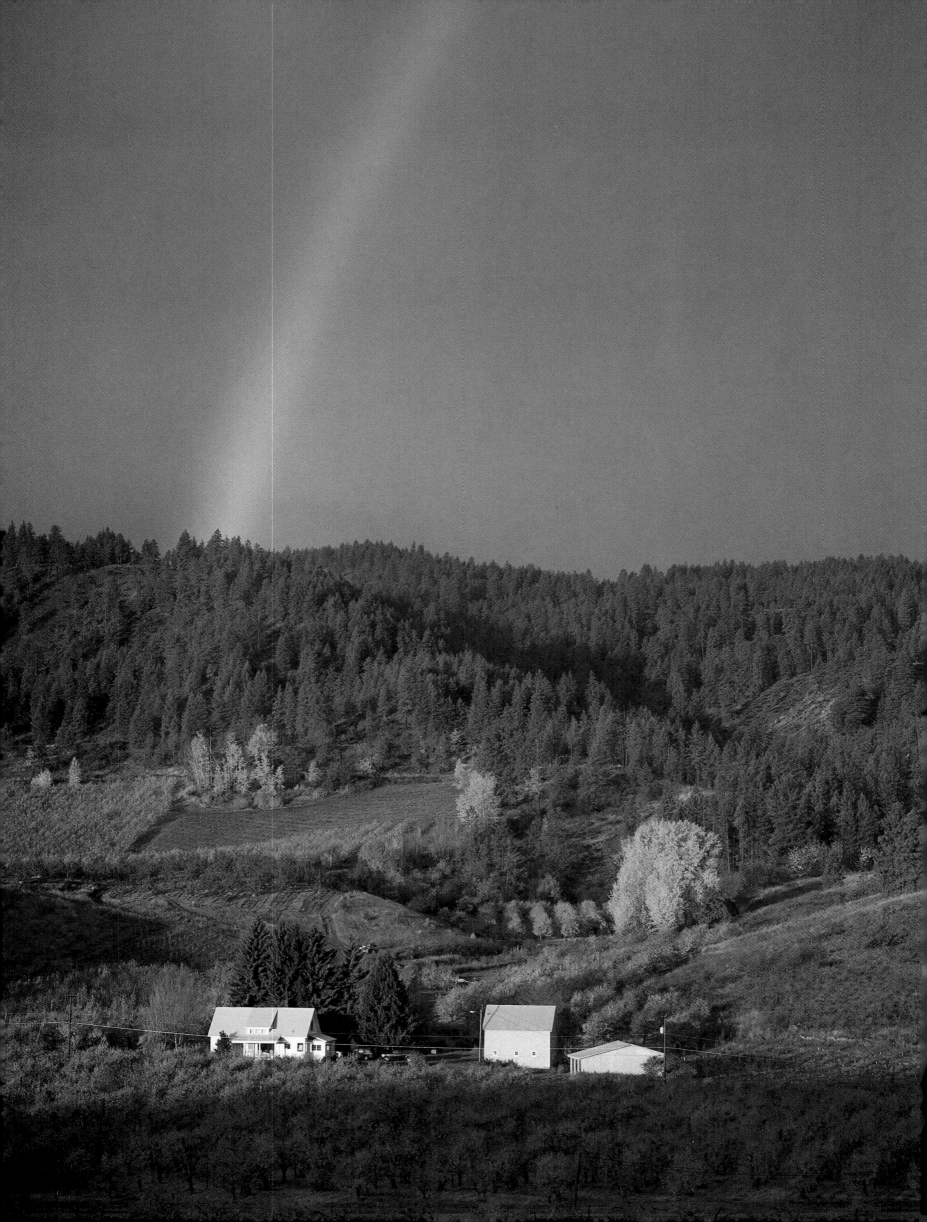

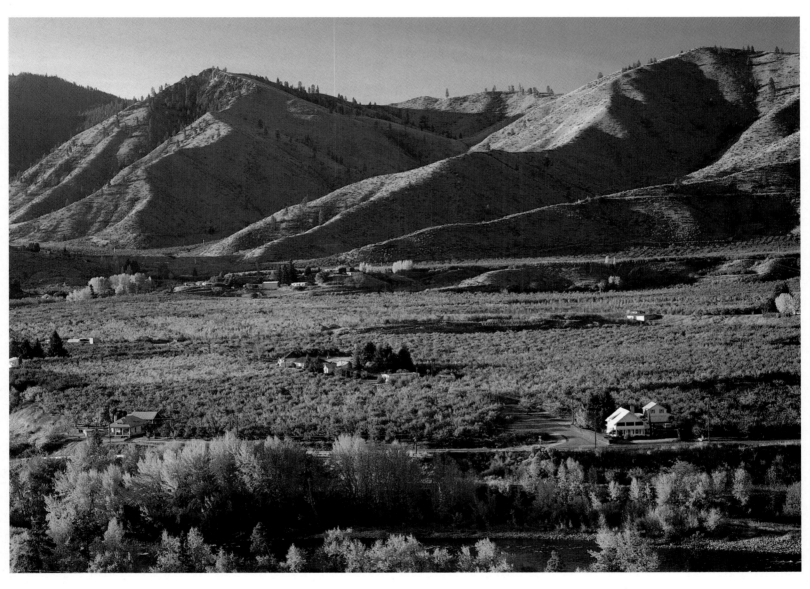

◁ A rainbow blesses a pear orchard and the forested foothills of the Washington Cascades, just east of Leavenworth. △ Dry foothills of the Washington Cascades stand in stark contrast to the lush, irrigated valley below. ▷ ▷ Red Delicious are ready to pick near East Wenatchee.

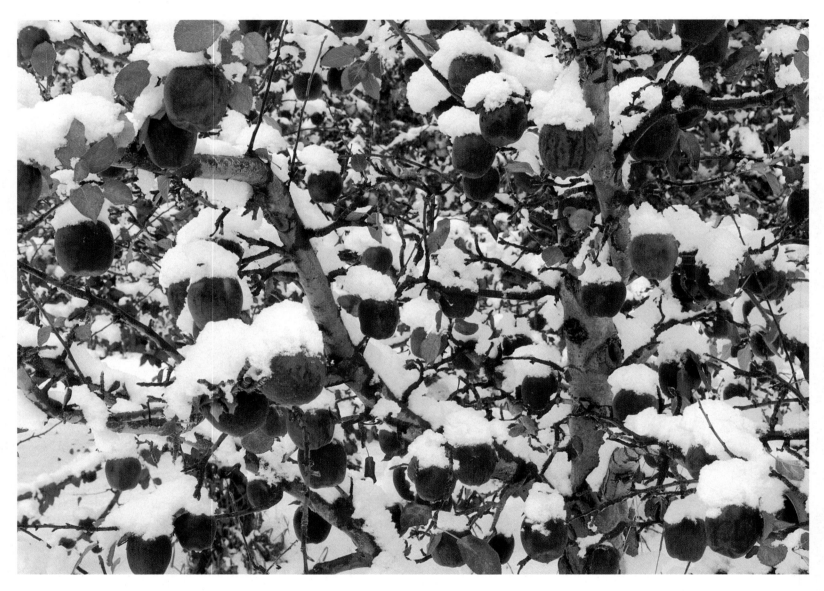

△ Snow-topped Red Delicious are an unusual sight. The fruit on this tree did not live up to the orchardist's expectations for size and color by normal harvest time, so it was left unpicked. ▷ Life slows down during the cold winter months. Orchard trees send their sap deep into their roots for protection from temperatures that can plunge well below zero.

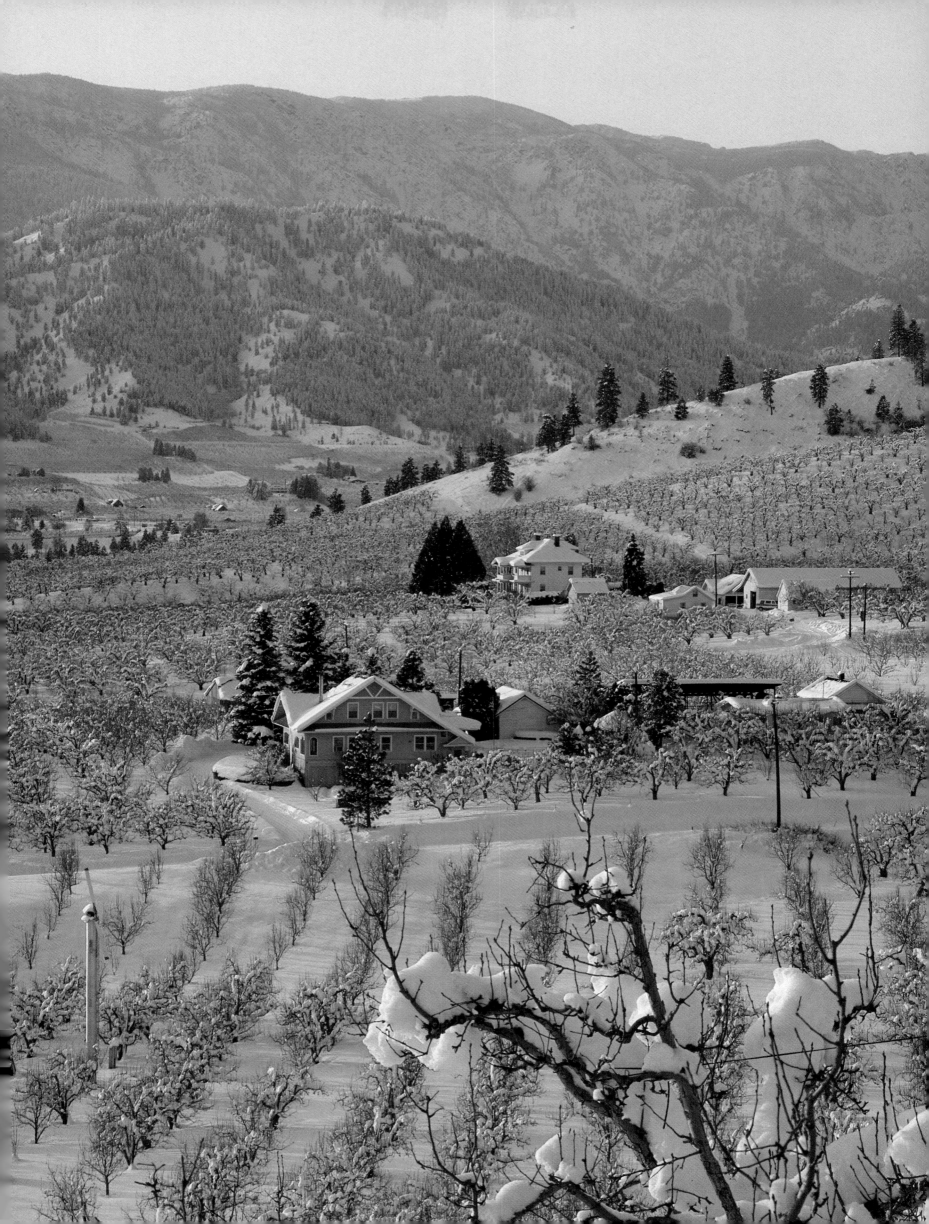

◁ Clematis blossoms and a glorisa daisy garnish a bowl of Bing cherries. Central Washington is the world's leading producer of sweet cherries, supplying the world with more than forty thousand tons annually. Some years, more than half that amount is exported. △ Golden Delicious apples hang above a row of mailboxes on a county road near Cashmere.

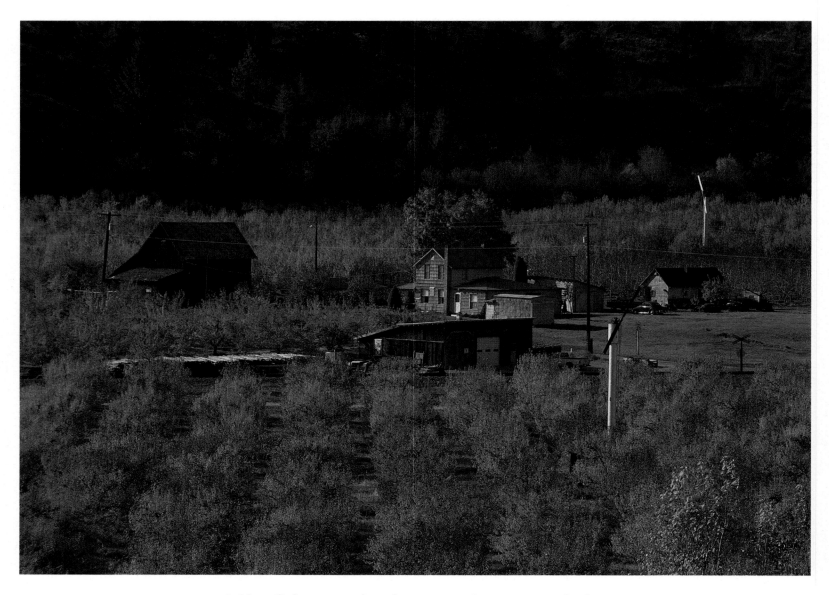

△ Near Cashmere, wind machines tower above a pear orchard in fall color. The machines are mainly used during frosty spring nights to mix warmer air above with colder air below. The process can keep fragile fruit buds from freezing as long as temperatures do not drop too low. ▷ Braeburn apples sit ready to eat in a basket woven from split ash.

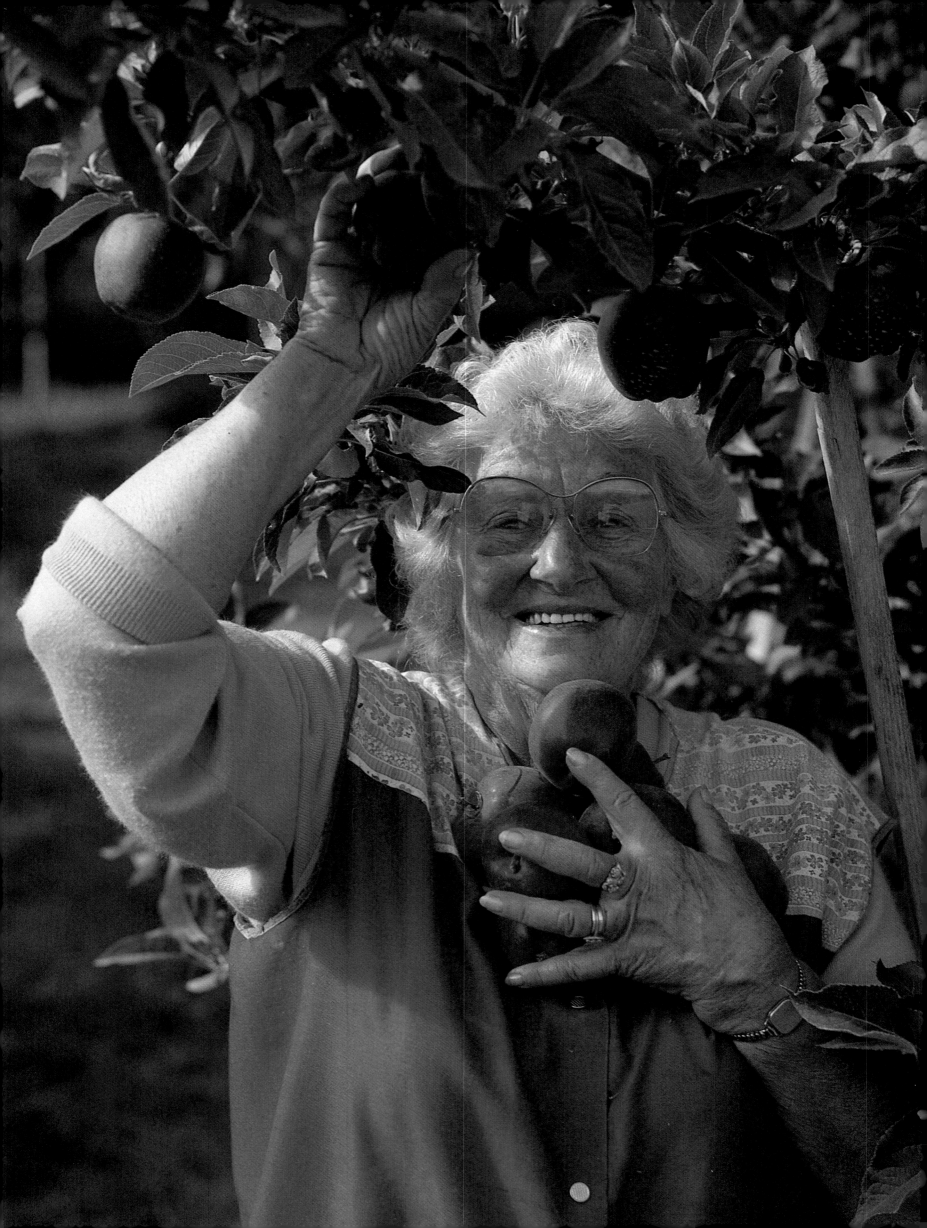

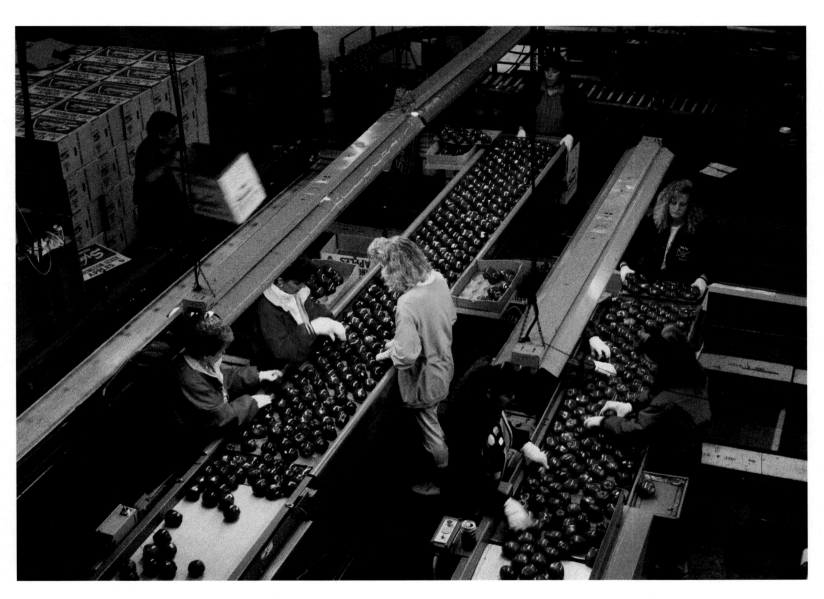

◁ Hilde Wierich's late husband, Albert, picked apples near Peshastin as a German prisoner of war. Orchardist George Cowan liked his work so much he invited Wierich and his wife, Hilde, back after the war ended. The couple worked and saved until they were able to purchase an orchard, which their son's family still operates. △ At a modern packing plant in Wenatchee, Red Delicious apples are automatically sorted for color, size, and quality and then placed in protective cardboard trays.

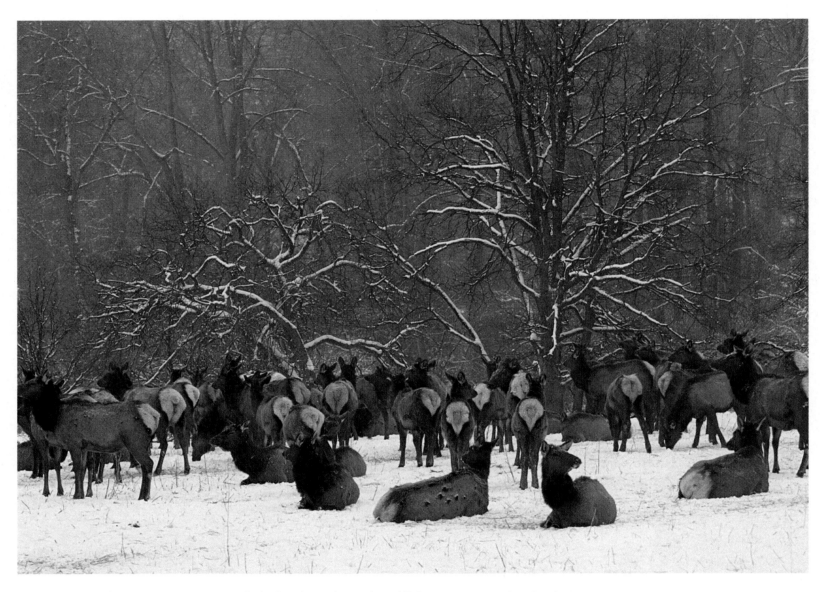

△ Elk feed at the Oak Creek Wildlife Area near Naches. Feeding areas such as this one help to keep deer and elk from feeding on tender orchard trees. During the snowy winters, the animals come down to the valleys from their summer mountain grazing areas. ▷ Bulls feed on bails of hay near Ellensburg, a dryland ranching area between principal orchard districts that lie closer to Wenatchee and Yakima.

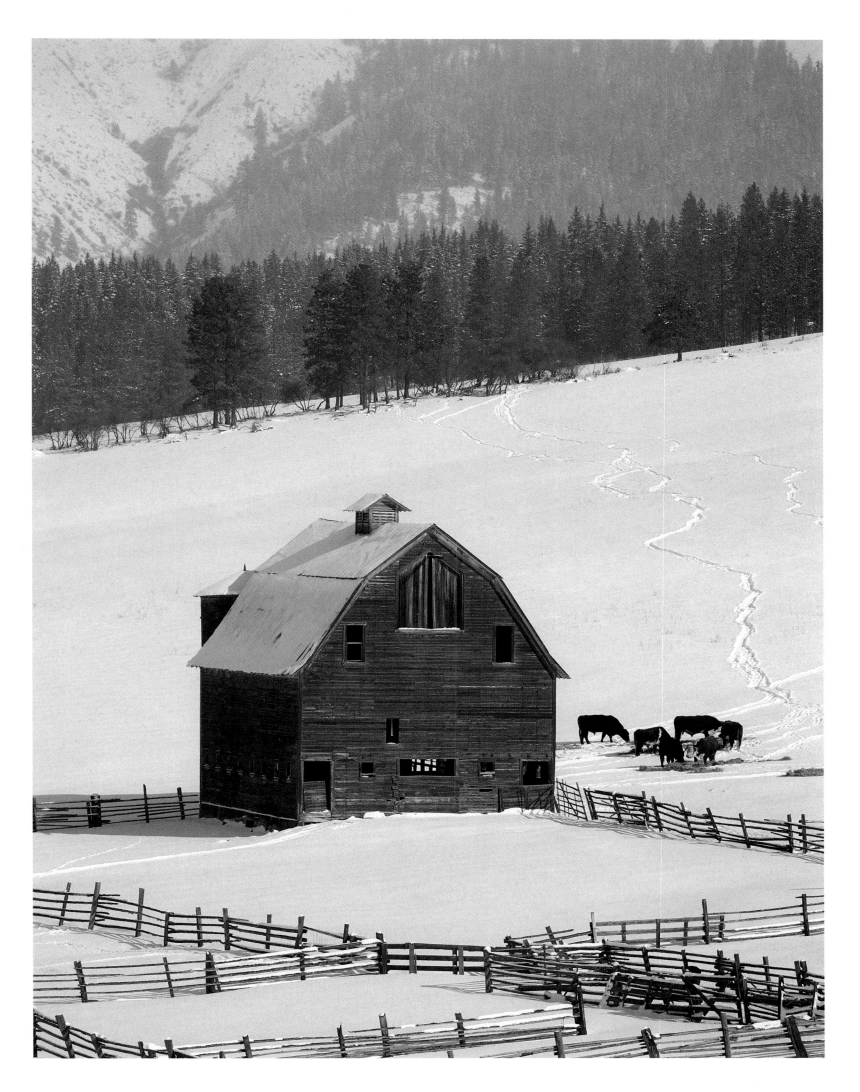

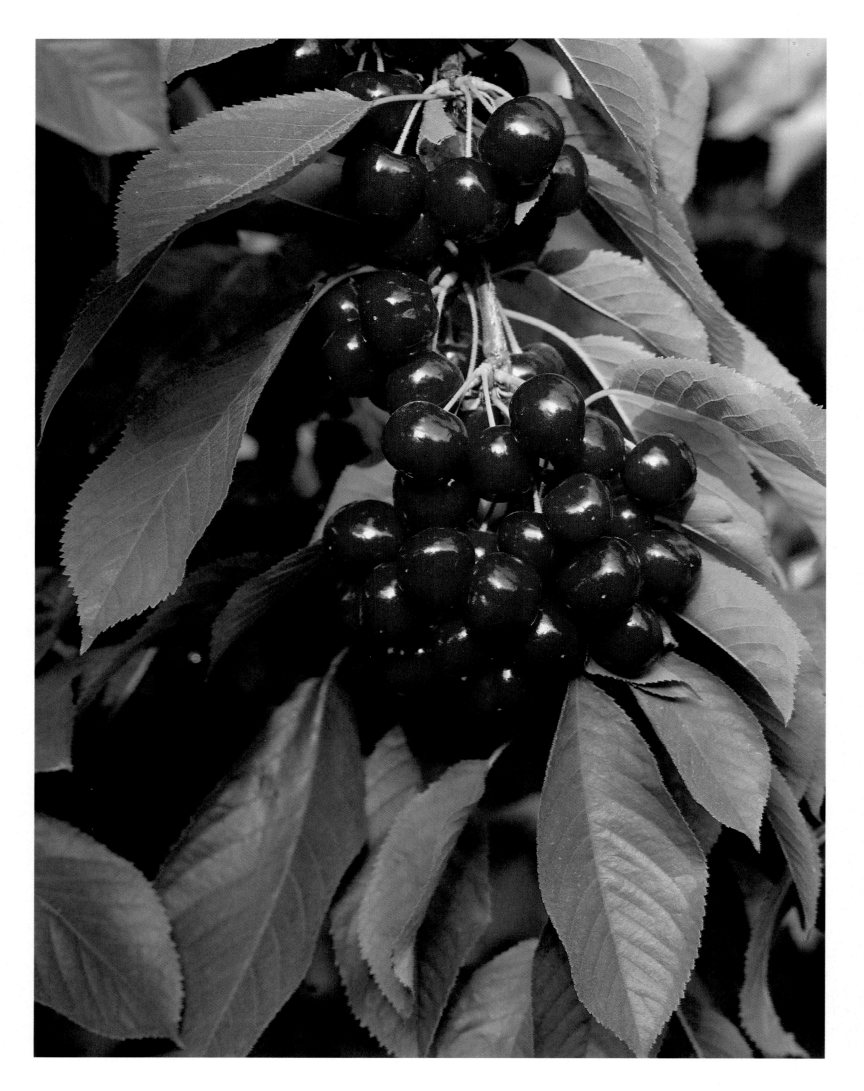

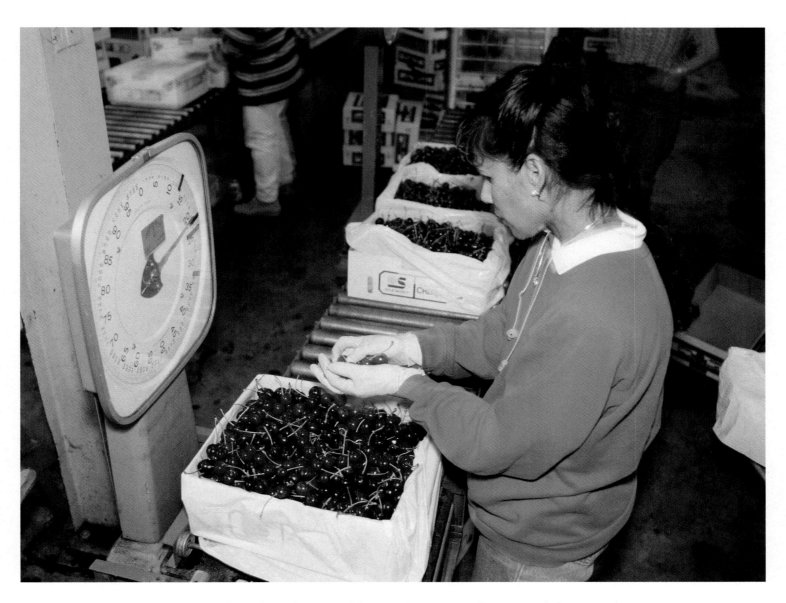

◁ The high productivity of the Van cherry tree makes it a good choice as a pollenizer for Bing and Lambert cherry orchards. Although the Van does not keep as long as other popular black cherry varieties, some people prefer its taste. △ A box of cherries is placed on the scales in packing at Snokist Growers to make certain it weighs the right amount.

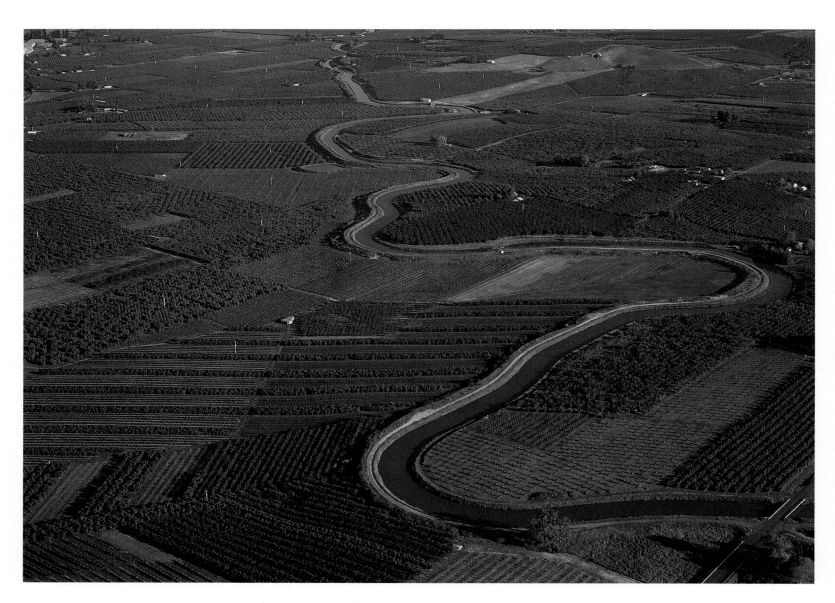

△ Wide irrigation canals bring water to thousands of acres of arid land, transforming the Yakima Valley into a lush producer of fruits and vegetables. ▷ Only California produces more nectarines than Washington. The Red Supreme nectarine, which tastes like a peach without fuzz, is the most common variety planted. ▷▷ Apple orchards follow the contour of Rattlesnake Hills near Parker. The pink hue is cheat grass; in late spring, as cheat grass dries out and turns from green to brown, there is a short time when it takes on a purplish-pink color.

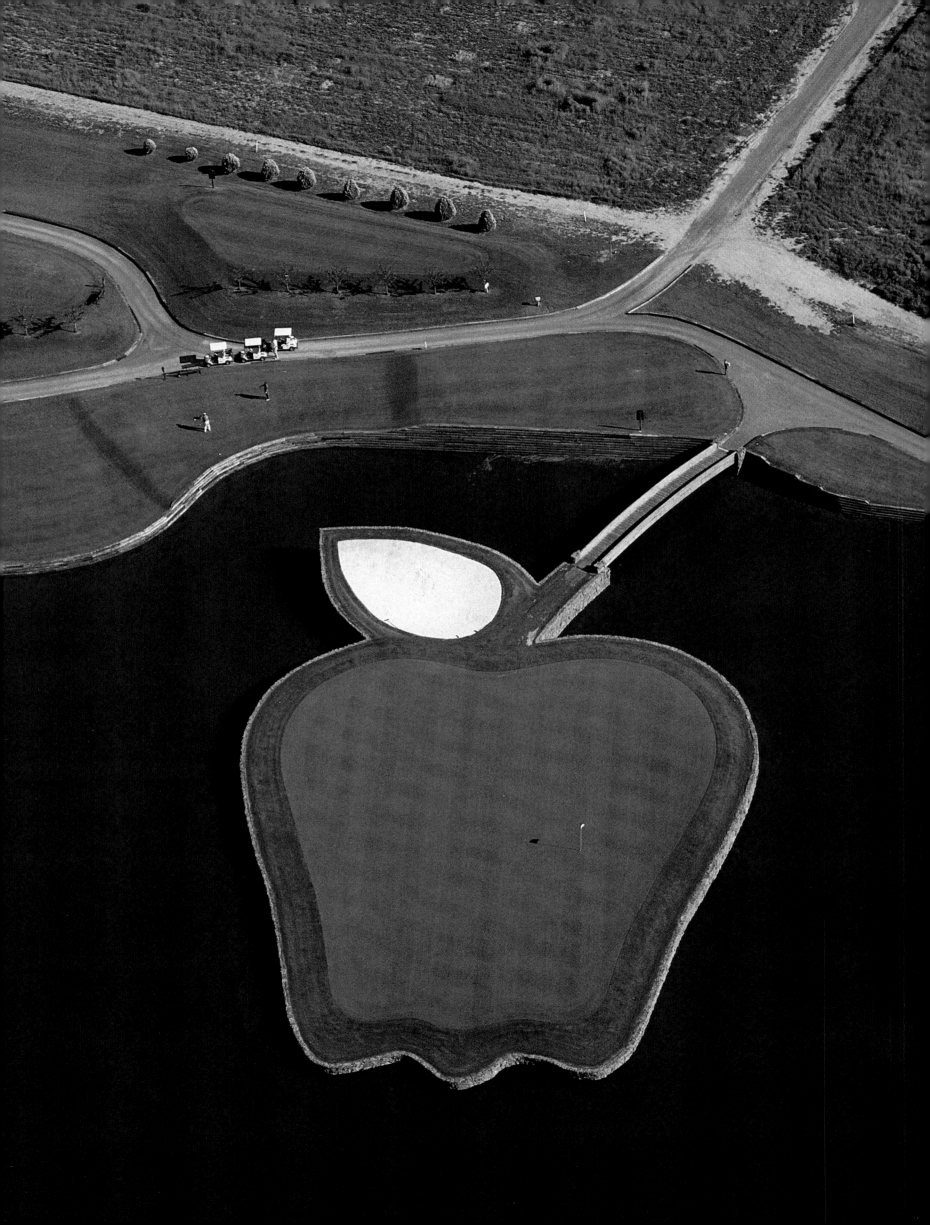

◁ Former President George Bush is only one of many golfers who have
found the water at the seventeenth hole of the Apple Tree Golf Course
in Yakima. The golf course was once an apple orchard. △ A fruitstand
offers delicious testimony to Central Washington's mid-August bounty.

△ A picturesque bridge crosses the Sunnyside Canal heading toward the Rattlesnake Hills in the Yakima Valley. ▷ A dusty orchard road snakes through apple trees in fall color near Naches. Suddenly relieved of fruit, apple trees gradually turn dormant in order to store and regenerate their nutrients for another year and as protection from winter.

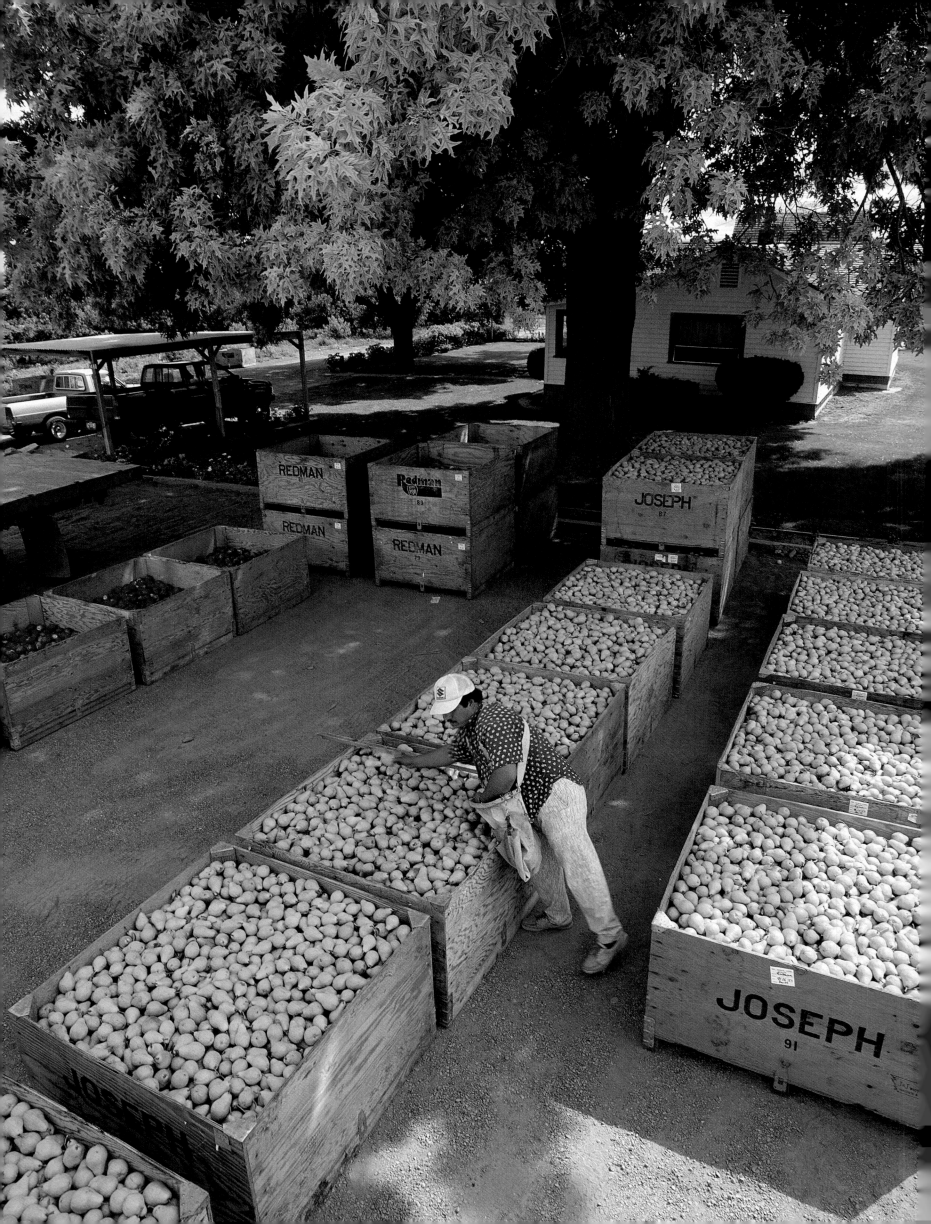

◁ Bins of green Bartlett pears are checked for bruises and punctures that can lead to decay in storage. Bartlett pears are sold to canneries for processing as well as packed for the fresh market in the fall. △ A fruit market displays a wide variety of produce, including apples, peaches, pears, nectarines, and potatoes—all fresh products of the Yakima Valley.

△ Yakima Valley and the Columbia Basin are also called wine country; the areas' wines have won awards worldwide for their fruity character. ▷ Mature Cabernet Sauvignon grapes are ready to pick and press. The state gained early notice for its white wines, but has recently been heralded for its luscious reds as well. Geographically, it is similar to the famed wine-growing regions of northern France and southern Germany.

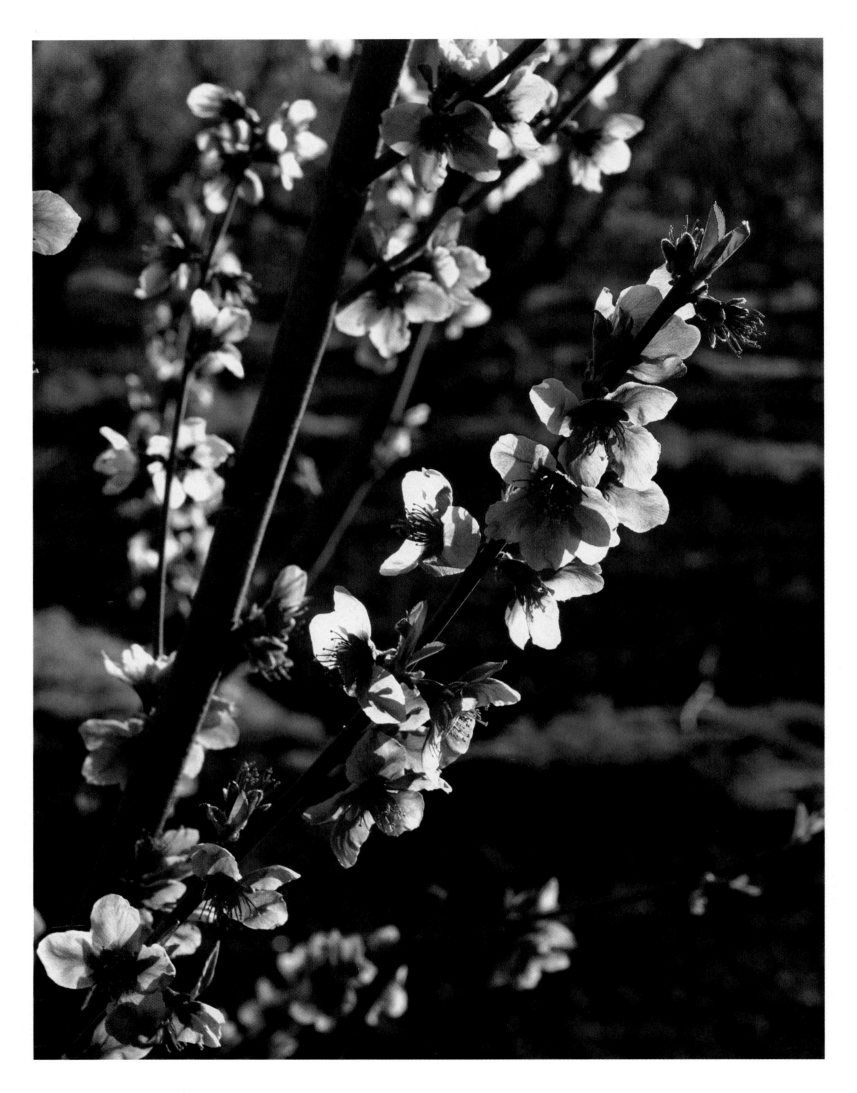

◁ Peaches are among the earliest fruits to bloom in Central Washington. The Yakima Valley is one of the country's leading producers of the juicy, mid-summer fruit. △ Old apricot trees like the ones in this Benton City orchard are rarely picked for commercial use. Older varieties have largely been replaced by firmer apricots that can be packed and shipped more successfully. This one-time orchardist now runs cattle on his land and picks the fruit only for personal use.

△ Mount Adams is a luminous backdrop beyond a young cornfield and orchard near Zillah, in the lower Yakima Valley. ▷ Years ago, red blushed Golden apples such as these were considered culls. Now, a strain of highly colored Blushing Goldens are cultivated for those who are willing to pay the price for a crimson daubed yellow apple.

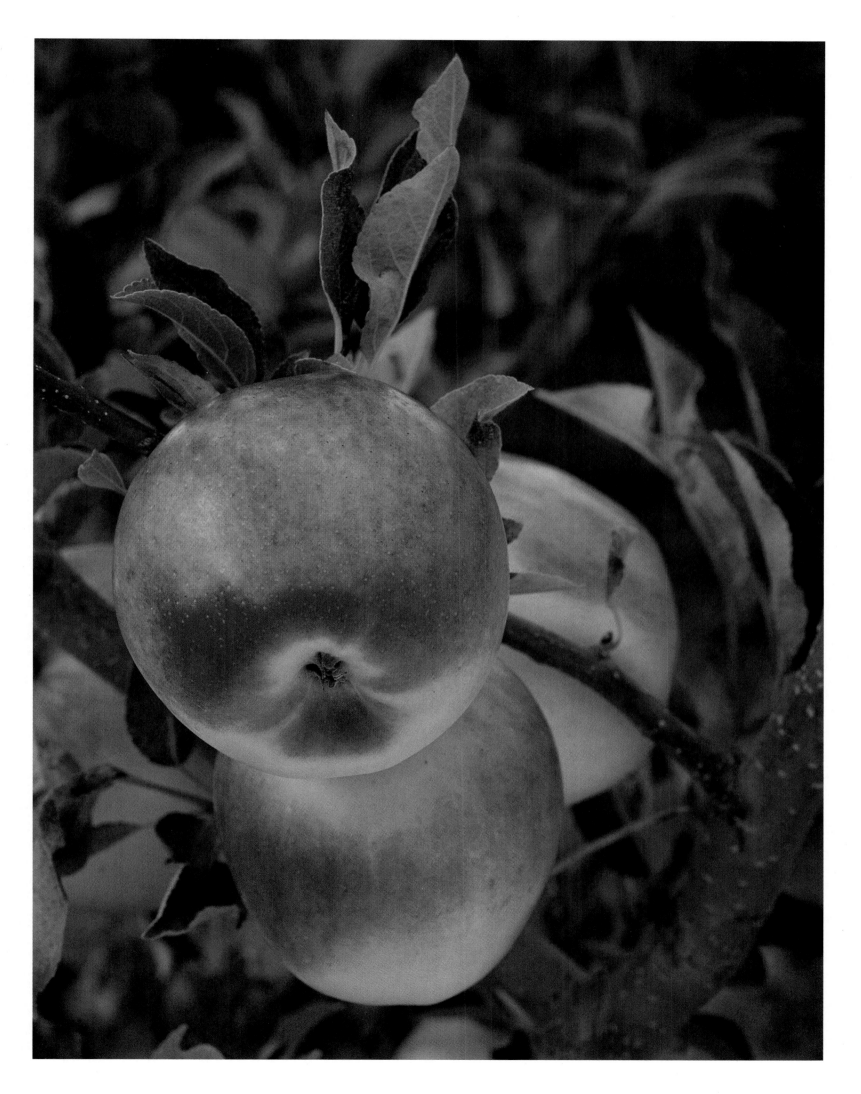

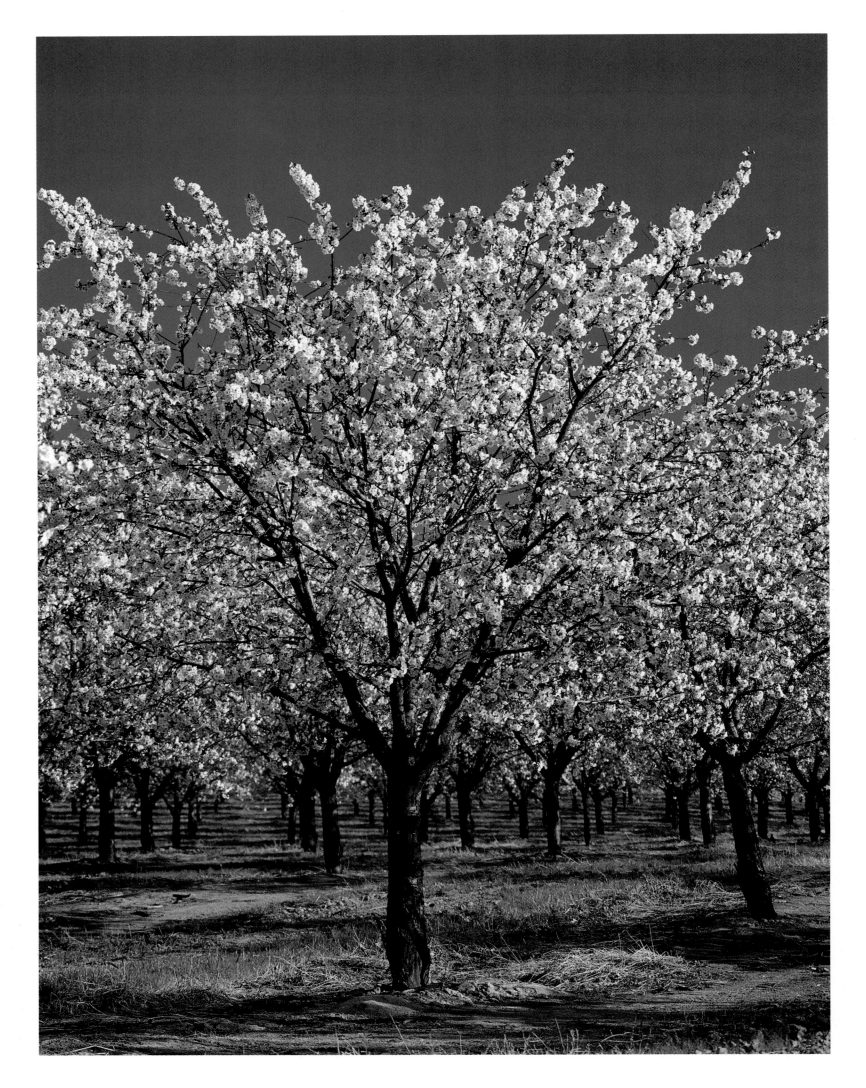

◁ Italian prunes are an important crop in southeastern Washington. The teardrop-shaped purple plums can be marketed fresh—or dried, as prunes. This orchard was caught in full bloom near the Horse Heaven Hills, south of Habton. △ These tiny, cranberry-red crabapples will never be picked. For cross-pollination purposes, the prolific-blooming variety of fruit trees is interspersed with other apple varieties that have commercial value. ▷ ▷ Between Ellensburg and Yakima, fall colors paint the cottonwoods and willows along the Yakima River Canyon.

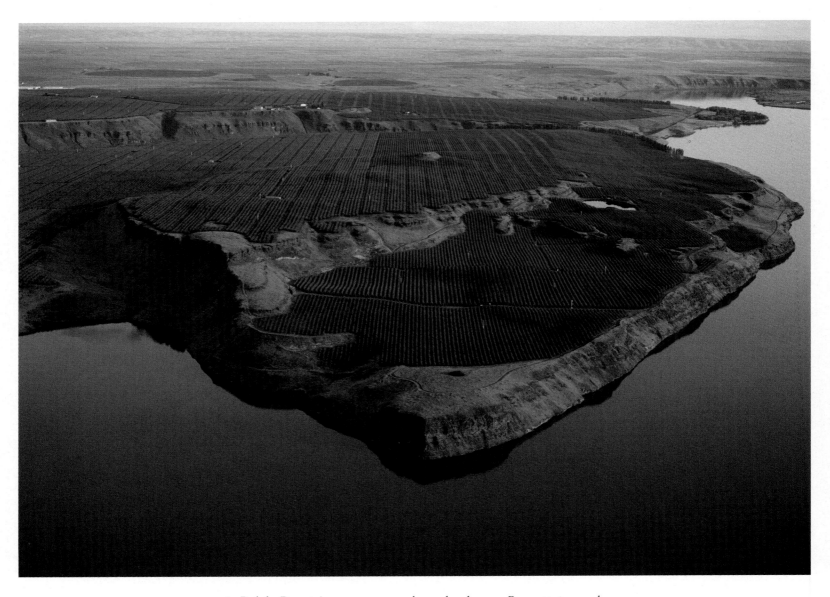

△ Ralph Broetje's enormous apple orchard near Prescott is nearly surrounded by the Snake River. Recently, the desolate area's low property prices and water availability have made it attractive to orchard entrepreneurs. ▷ Harvesting Fujis can continue until November.

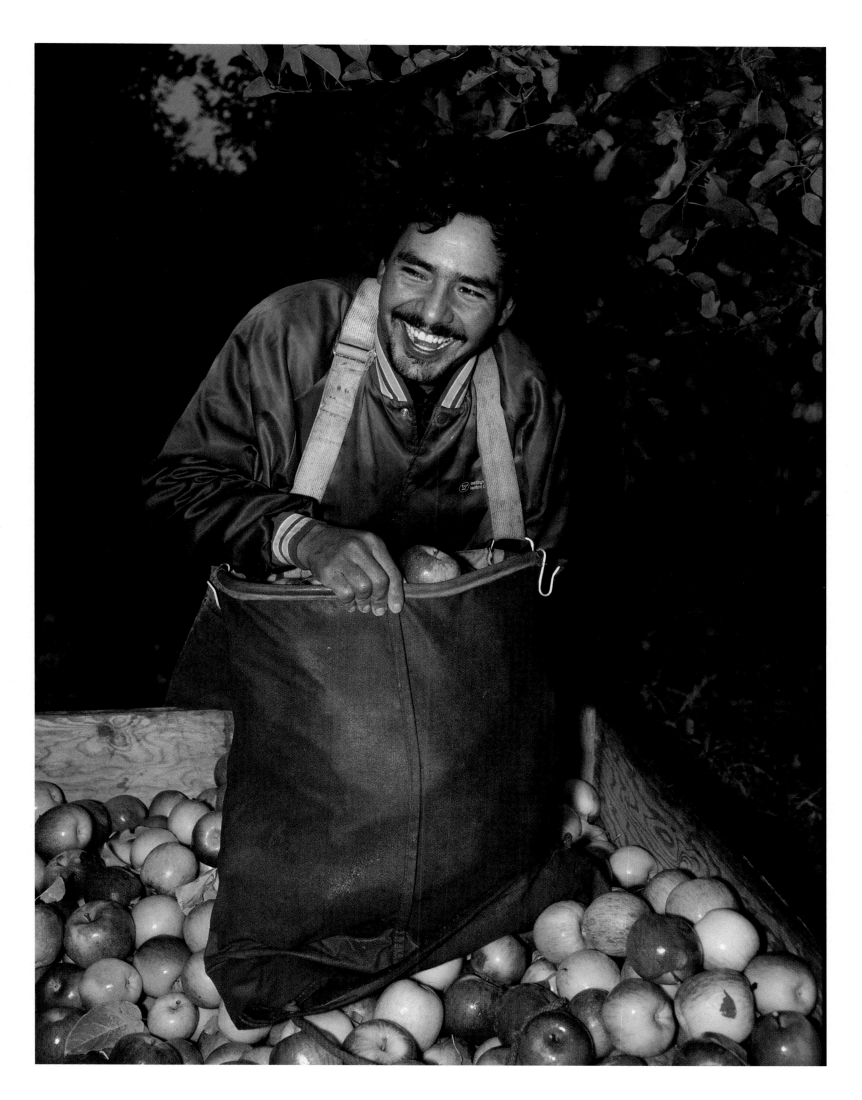

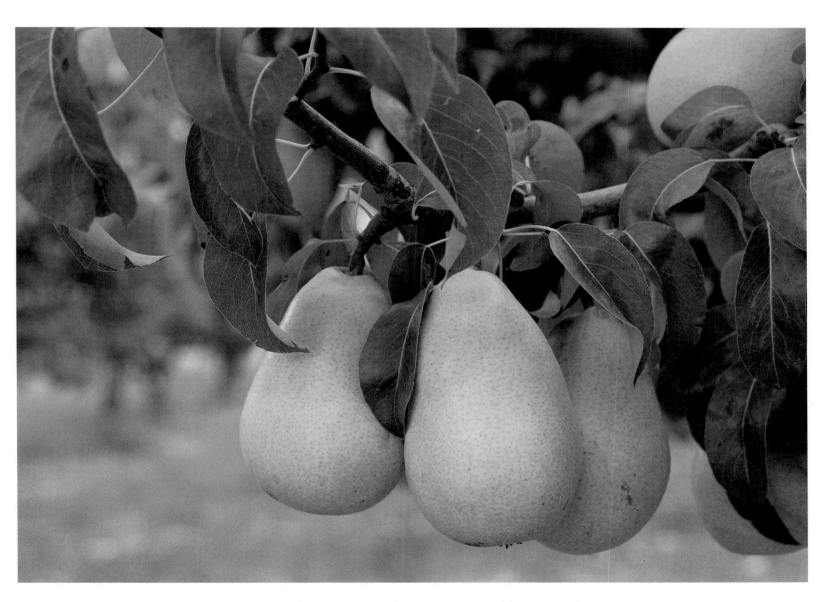

◁ A canoe adds color to a landscape of locusts and big leaf maples at the mouth of the White Salmon River on Northwestern Lake. △ The main crop grown in the White Salmon region is the d'Anjou pear. When the d'Anjou is ready for picking, it does not look like these; this tree was apparently missed at harvest, so pears have ripened on the tree.

△ Brilliantly colored vine maple contrasts with bracken fern and young Douglas fir on a previously cut forest near Willard, close to White Salmon in Skamania County. ▷ Scarlett colored Jonagolds grow near salty Padilla Bay in Western Washington. ▷ ▷ A Central Washington fruit stand in October is a colorful cornucopia of sumptuous produce.

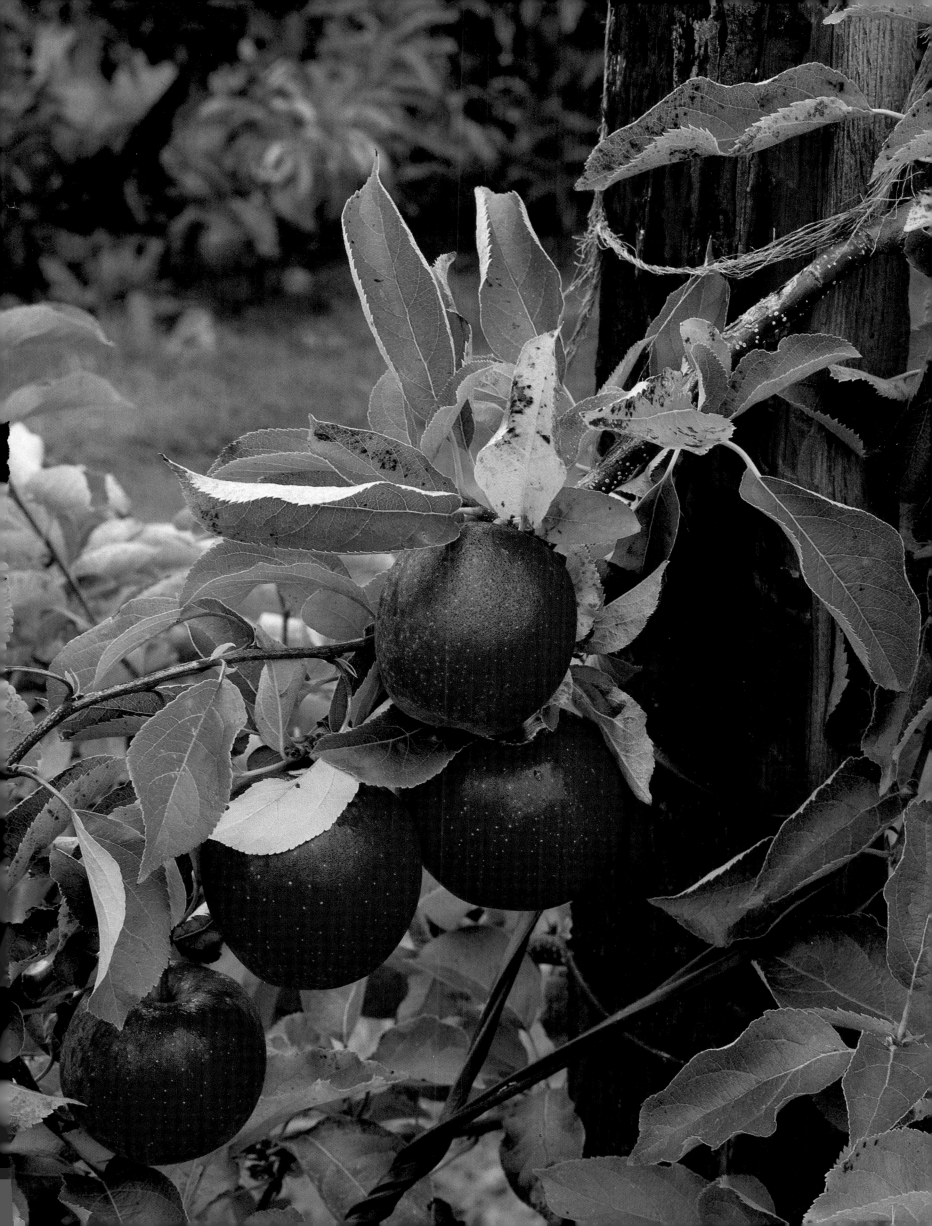

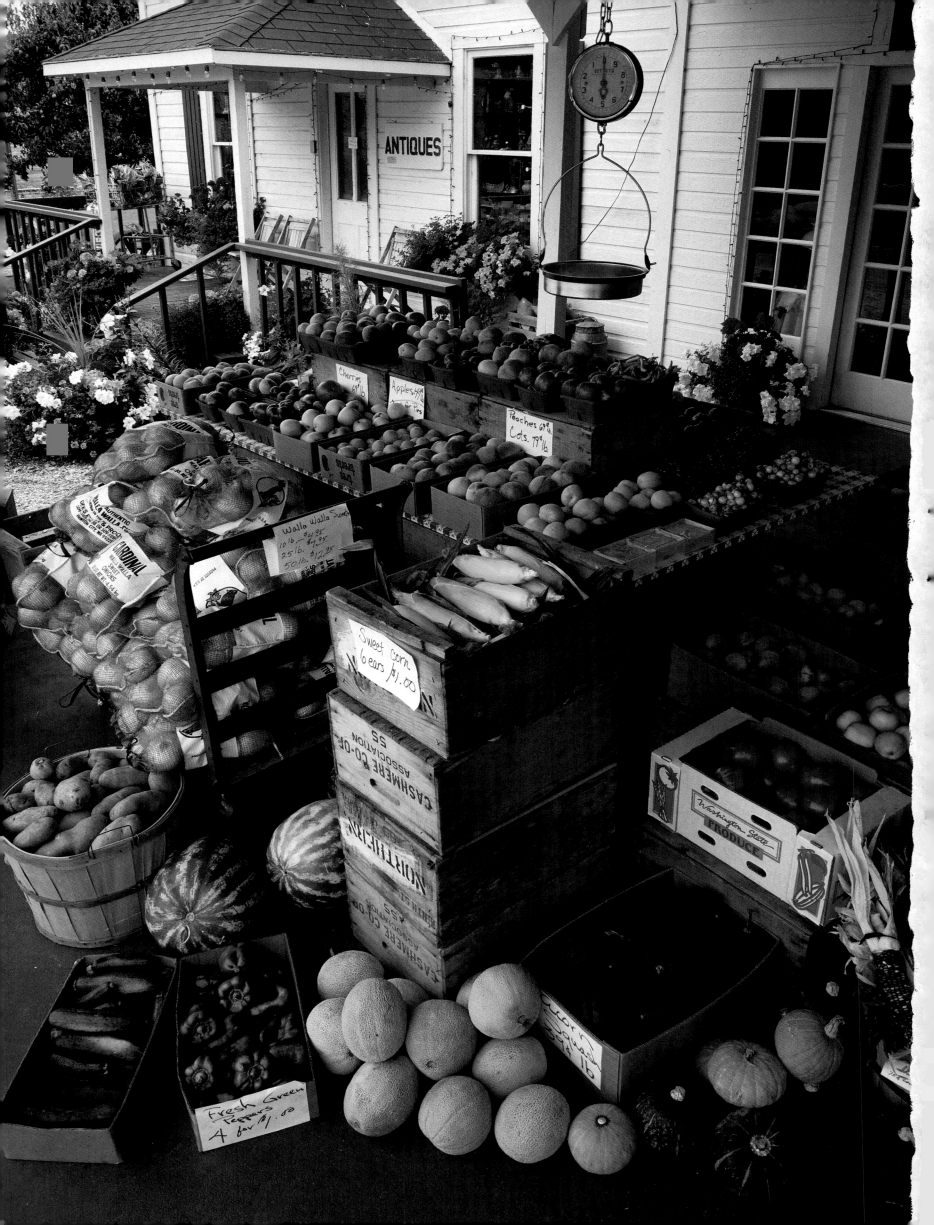